Red House

Phaidon Press Limited
Regent's Wharf
All Saints Street
London N1 9PA

First published by Architecture Design and
Technology Press 1991
Reprinted by Phaidon Press 1993, 1996

© 1991 Phaidon Press Limited

ISBN 0 7148 3130 1

A CIP catalogue record for this book
is available from the British Library

Printed in Singapore

Red House is a private residence and may
be visited only by prior written appointment.

To Doris

Red House
Philip Webb

Edward Hollamby
ARCHITECTURE IN DETAIL

Foreword

When in 1953 my radio talk on Red House was broadcast, not many people – I suspect – had ever heard of the house, let alone visited it. Certainly it was difficult enough to find, in suburban Bexleyheath on the edge of Kent.

But in recent years the house has become a centre of pilgrimage for young people from all over the world, many of them architects and students. Indeed, to architects it is one of the most famous buildings in England.

Red House was designed by the young architect Philip Webb for his friend and fellow designer William Morris, as a home for Morris and his young wife, the pre-Raphaelite model Jane Burden; as a workshop and studio; and as a meeting place for their friends.

Webb and Morris were young, idealistic and reformist. Inevitably their house was more than just a house. It was a statement, in three dimensions, of principles and beliefs, a challenge to the tyranny of the machine, and a call for a return to human values. It was formed and shaped in simplicity from traditional materials - brick and tile, robust walls and massive barn-like roofs. It all sounds ordinary enough, perhaps; but at the time it was built, more than a century ago, it represented a quiet revolution.

For the past thirty-eight years, shared at first with other young friends with similar ideals, Red House has been the family home of the architect Edward Hol-lamby, who in the following pages records its history and assesses its importance in the development of modern architecture in England.

Not all the architectural conventions of the mid-19th century were challenged in the design, which like other middle-class homes at that time relied firmly on a ready supply of cheap domestic labour. The house was heated by coal fireplaces, and hot water by a 'copper' in the scullery; there were no bathrooms; and the servants slept in a dormitory, albeit on the first floor – no garrets here!

Nevertheless, the Red House has shown itself to be extraordinarily adaptable to changing styles of domestic life, and it is easy to understand how this handsome yet modest dwelling and secluded garden attracted and held the respect of its present owner. He clearly welcomes its idiosyncrasies, admires its austere but robust detailing, and he writes about it with the same directness and simplicity that inspired its designers.

It is the success of this unpretentious record that not only are we allowed to share in the author's evident enthusiasm for the building, but that we catch again an echo of the civilizing principles upon which this house – Red House – was so securely built.

Sir Hugh Casson
London April 1990

The genesis of Red House

The idea of building Red House was conceived by William Morris in the summer of 1858, which found him on an eccentric boating trip in France – rowing down the Seine with his friends Charles Faulkner and Philip Webb.

The Oxford 'Brotherhood'

Morris was an exceedingly uncommon man – with an astonishing range of interests and talents. At Oxford he had been a member of the 'Brotherhood' (a group of young writers and poets under the influence of Carlyle, Ruskin and Tennyson); had formed what was to become a life-long friendship with a fellow student, Edward Burne-Jones; and had begun to write poetry and study medieval architecture. In 1856, returning to Oxford after a visit·to the cathedrals of Northern France with Burne-Jones, the two friends met the artist Dante Gabriel Rossetti. Under Rossetti's influence Burne-Jones resolved to take up painting, while Morris decided on architecture and apprenticed himself to the Gothic revivalist architect, George Edmund Street.

Morris takes up architecture and meets Philip Webb

It was in Street's office that Morris had met Philip Webb, who at that time was Street's 'senior clerk'.

Between these two men, so different in character and temperament, was borne a life-long friendship, and an enduring comradeship, soon to bear fruit in the design and building of Red House.

After a year with George Street, Morris abandoned the idea of embracing architecture as a profession and took up painting under the tutelage of Rossetti, sharing a studio in Red Lion Square with Burne-Jones. But that ambition, too, he rejected after a year, doubting his competence to succeed as a painter. Not for nothing had he adopted Jan Van Eyck's motto – 'Als ich kanne' (if I can), later to appear as 'Si Je Puis', in some of the stained glass and tiles at Red House.

The conception of Red House

Now, a year later in 1858, a new sort of 'Brotherhood' was going through Morris's mind – an association of artists/designers/craftsmen, in which the work of mind, eye and hand would play complementary parts. Morris's impending marriage to Jane Burden, the beautiful Pre-Raphaelite model who Rossetti had introduced him to, had set him thinking about building a home – and what better than to make the building, and the decorating and furnishing of it, the opportunity to establish the new 'fraternity'.

These were the thoughts of Morris as he and his friends rowed down the Seine; and here the idea of Red House began to take shape. Lethaby tells us

that at the back of one of the maps in Morris's copy of Murray's Guide to France he found 'a hurried sketch by Webb of the staircase tower of a house rising to two finials'; and he comments 'it must be the first idea for the staircase projection at Red House'.

The search for a site

After Morris and Webb returned to England there was much travelling about to look for possible sites for the house. The site eventually decided upon[a] was in an orchard in the little hamlet of Upton at Bexleyheath.

One may ask, why Bexleyheath? Morris was an Essex man, but Mackail says that 'till he went to live on the Upper Thames (at Kelmscott), Kent was probably his favourite county'. The London and Greenwich railway had recently been extended as the North Kent Line, and Abbey Wood station on the Plumstead marshes – close to the ruins of Lessness Abbey – was near enough for convenient travel to and from London.

But what was surely of greater significance was that the great Chaucerian route of the Canterbury pilgrims, passing over Shooters Hill, runs – as the ancient Watling Street – straight as a die through Bexleyheath. We may therefore safely assume that the site for that 'small Palace of Art of my own' was deliberately chosen to be close to that ancient track of medieval England. Indeed Morris called the garden porch of Red House 'The Pilgrim's Rest'.

Designing and building Red House

The site once chosen[b], Webb's design for the house was swiftly produced. Construction started in 1859. While Red House was being built, Morris and his wife resided at Aberleigh Lodge alongside his orchard. He would therefore have been able to oversee its construction day by day. Whether Morris was actually involved at this stage it is hard to say. Webb would certainly not have allowed that with any of his other clients. But between these two men there existed a very special bond, and certainly in the design of the house, and in its furnishing and decoration, the roles of Morris and Webb were closely intertwined. Aymer Vallance goes so far as saying that 'Philip Webb ... was merely carrying out Morris's directions', though he qualifies this in adding 'more particularly in the design of the internal fixtures'.

Undoubtedly the design of the house was a unique work of collaboration between artist/designer, client and architect. Lethaby wrote that 'the early work of Webb and Morris was so interwoven that we cannot tell in some instance where the work of one man began and the work of another finished'.

Red House thus became a blend of the romanticism of Morris and the pragmatism of Webb, united in a common philosophy of art and architecture largely derived from Ruskin, who argued first in the Seven Lamps of Architecture, and more particularly in the

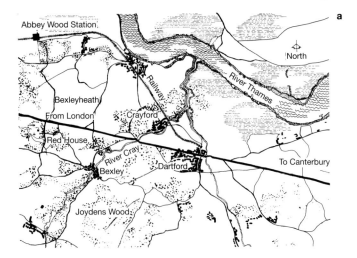

a

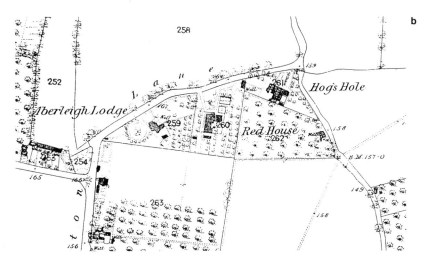

chapter 'Of the Nature of Gothic' in *The Stones of Venice*, that a building had to be truthful before all.

'O the joy of those Saturdays to Mondays'

William and Jane Morris moved into their new home at the end of the 'wet' summer of 1860. It immediately became 'open-house' for all their friends. 'O the joy of those Saturdays to Mondays at Red House', wrote one of them, 'the getting out at Abbey Wood Station... and then the scrambling, swinging drive of three miles or so to the house; and the beautiful roomy place where we seemed to be coming home, just as much as when we return to our own rooms...'. 'It was a country place then' wrote Georgiana Burne-Jones 'and we were met with this fresh air full of sweet smells'.

The wagonette sent to meet the friends at Abbey Wood Station was designed by Webb and built at Bexley. May Morris described it as being 'like an old fashioned market cart' ... covered with a tilt of American cloth, lined with gay chintz hangings. William and Jane used to go for 'little jaunts with their friends' in it, to the merriment of the locals who thought 'they were the advance guard of a travelling show'.

Weekends were spent in fun and games, bowls in the garden and decorating the house.

House and garden conceived as one

Red House and its garden were designed as one; and there is a special harmony between the house – solid and romantic – and its setting.

Mackail described the garden 'with its long grass walks, its midsummer lilies and autumn sunflowers' as being then 'as unique as the house it surrounded'. Other accounts tell of orchard walks and flower beds bordered by lavender and rosemary. Climbing plants were placed against the walls – roses, white jasmine, honeysuckle, and that most symbolic of all flowers, the 'passion flower'. They were even marked on Webb's elevational drawings. 'Morris's knowledge of architecture' writes Mackail 'was so entirely a part of himself that he never seemed to think about it as anything peculiar. But in his knowledge of gardening, he did, and did with reason pride himself'... 'of flowers and vegetables and fruit trees he knew all the ways and capabilities'.

House and garden were planned to retain as many of the orchard trees as possible. The lawn on the west side of the house was where Morris and his friends played bowls – later, croquet was played on the front lawn.

In her 'Memorials of Edward Burne-Jones', his wife, Georgiana described 'four little square gardens making a big square together, each of the smaller squares having a wattle fence round it, with roses growing thickly'. The little square gardens have now disappeared, but there is still a square hedged area, which may have been one of them, or – more likely – the big square that contained them. This is confirmed

if one examines the first edition of the Ordnance Survey dated 1860, and drawn in such beautiful detail that one can see almost every structural detail of the garden as it was then. Many of the old fruit trees – apple, pear, plum, damson and quince – survive in the garden and orchard today, and the structure of the garden though modified in detail remains substantially as Morris laid it out.

Furnishing and decorating Red House

But if garden and house could be created as one, its furnishing and decoration was a different matter. May Morris wrote of her father 'when he came to the furnishing of Red House, nothing could be found that would satisfy him' and Mackail recorded that 'not a chair or table, or a bed; not a cloth or paper hanging for the walls; nor a curtain nor a candlestick; nor a jug to hold wine or a glass to drink it out of, but had to be re-invented'.

Undaunted by this, the weekend visits by his friends were turned into working parties. Burne-Jones and Rossetti painted tiles, glass and furniture, most of the latter designed by Webb. Morris designed flower patterns for ceiling and wall paintings and for wall hangings which Jane and her sister embroidered in wool. As well as tables and other furniture, some of which (like the great sideboard in the dining room) were built into the fabric of the house, Webb designed beau-

tiful table glass and metal candlesticks. Even Faulkner, a mathematician, was given geometrical ceiling patterns – pricked out in the wet plaster – to paint. Walls were distempered in pale colours and great plans for wall paintings were made; scenes from the Trojan walls were to go up the stairs, and a great ship carrying Greek heroes was to adorn the hall below.

Bizarre some of these decorations might have been, as the pre-Raphaelite painter Bell Scott observed on a visit; but 'the explanation' he thought was that it was a young man's house and 'genius always rushes to extremes at first'.

The 'Brotherhood' becomes the 'Firm'

This was the happiest time of Morris's life. Out of their work on Red House, the friends conceived the idea of 'the firm' – which was eventually to become the manufacturing and decorating firm of Morris, Marshall, Faulkner & Co. in which Rossetti, Burne-Jones and Philip Webb were also partners, and which had a profound influence on industrial design and interior decoration in England in the latter part of the 19th century. Thus did the romantic search for a monastic 'Brotherhood' at Oxford come to terms with the economic realities of the 19th century, and find its fulfillment as a Victorian business.

Even then the appeal of the ivory tower was so strong that there was talk in 1864 of bringing the workshops back to Upton, and extending Red House in a

courtyard form for the Burne-Jones's. Webb even prepared designs for such an extension.

The end of the dream

In a few short months, a series of misfortunes which affected the health of both families put an end to the dream.

Burne-Jones wrote to tell Morris that he and Georgiana would not be able to join the Morris's in an extended Red House as they had planned; and Morris, recovering from rheumatic fever, replied sadly:

> As to our palace of art, I confess your letter was a blow to me at first ... in short, I cried, but I have got over it now: of course, I see it from your point of view, but I like the idea of not giving it up for good even if it is delusive.

Soon, Red House was sold and on a cold autumn day Morris and his family moved to Queens Square. 'Morris' says Mackail 'never set eyes on it again, confessing that the sight of it would be more than he could bear'.

Red House today

Red House, built within an orchard, is reached today (as it was when newly built) by a narrow winding lane to the north, past the cluster of cottages known as 'Hogs Hole', which in 1860 formed the nucleus of the little hamlet of Upton.

The L-shaped house plan is therefore arranged with its entrance on the north side; with the entrance drive swinging round past it to the stable and coach house in the north-east corner of the site.

Nowadays, the house is surrounded by a typical London suburb. Yet, behind its red brick wall, and enclosed by lime, oak, horse chestnut and hawthorn, with its birdsong and with its fruit trees laden with blossom in the spring, it is still idyllic, like an oasis.

Sir Hugh Casson described Red House in a radio broadcast in 1953 as 'suddenly rearing up like a miniature Camelot of turrets and steeply crested roofs above its surrounding wall'. It is an image that recalls Ruskin's prescription, that a house should have a conspicuous roof 'which is its very soul'...'wherein consists its shelter', and in which 'its whole heart and hospitality are created'.

If the great red tiled roof – broken by gables, hips, valleys and ridges at different levels – is still the most prominent external feature, the walls of bright orange–red bricks laid in 'English Bond' and set in lime mortar with white flush jointing, now mellow, must have been startling in their brilliant contrast with the yellow–brown bricks and stucco of the slate roofed houses and cottages of Upton. Morris's awareness of the effect of sharp contrast of bright red bricks is shown in the poem 'Golden Wings', written in 1858:

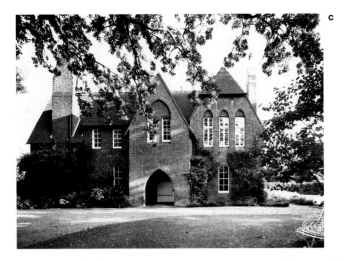

c

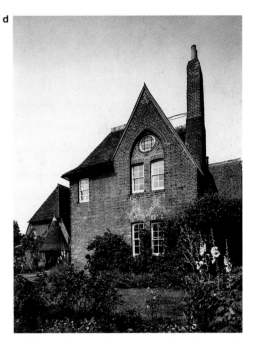

d

Many scarlet bricks there were
in its walls of old grey stone;
over which red apples shone
at the right time of the year.

Startling in its contrast to its surroundings as Red House undoubtedly was, the house and its garden were nevertheless sheltered and enclosed by the long red brick boundary wall much as they are today. Though the orchards and meadows have disappeared, when today's visitor passes through the solid wooden gates, it is to experience the illusion of entering another world, to find that house and garden in the country that Morris created.

The entrance boldly marked
The entrance to the house is immediately apparent in the severely bold pointed arch marking the deep entrance porch.[c]

But before entering, let us follow the brick path round to the east side of the house.[d] Here, in the internal angle of the L-shaped plan, one of its most characteristic and evocative features is revealed – the 'well-house', covered by a tall conical roof which is supported on massive oak posts.[e] This well-court (facing south and east, and therefore capturing the morning sun) was originally surrounded by a wooden trellis covered with roses in summer*. The well would have formed the centre-piece of a paved courtyard for

the proposed extension to house the Burne-Jones family, had it been carried out.

Opening onto the well-court is the south-facing porch Morris called the 'Pilgrim's Rest', entered from the outside through a massive pointed arch; and in the corner formed by the two wings is the staircase tower, rising to the sky and surmounted by turret and weather vane[e] bearing the engraved initials WM; the date, 1859; and the White Horse of Kent.

Continuing our walk round the house, we see at the south end a huge dormer window[f] with its own hipped roof, emerging from an uninterrupted roof slope to light what was originally the maids' dormitory (now a bedroom).

Moving on, the west elevation of the house[g] is dominated by an oriel window boldly supported and corbelled off a massive buttress – its form providing a fascinating counterpoint to the great chimney stack alongside, emerging from the solid brick walling to soar above the highest point of the roof. But seen from the orchard across the rose walk and the former bowling green it is the massively barn-like scale of the roof which dominates.

Returning to the entrance front on the north facade, one is aware of yet another change of mood – altogether sterner, almost forbidding, were it not for the bold and generous recessed entrance porch and the three tall lancet windows announcing the presence of the first floor drawing room.[c]

* This became the model for Morris's first wallpaper design, 'The Trellis'. Typical of their relationship, Morris drew the foliage, Webb the birds.

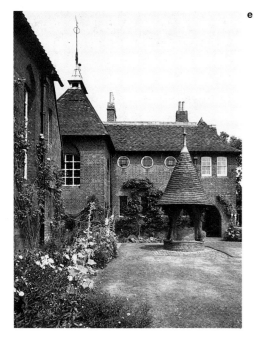

e

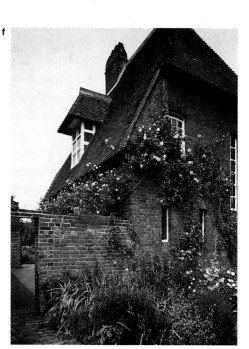

f

Function and relationship expressed in the fenestration

Mackail describes the house as being 'plain almost to severity' depending for its effect 'on its solidity and fine proportion'.

What is most remarkable externally is the freedom of the fenestration. Windows of different shape, type and size express with brilliant clarity the plan form behind them.

Pointed arches are used to provide massively expressive openings to the main entrance and to the garden porch. Elsewhere, used as relieving arches to shallow segmental arches to sliding sash windows, they sometimes contain a recessed tympanum to add scale, as for the vertical window to the back stairs and the paired windows over the entrance porch.

Narrow metal slit casements light stores and are inward opening. Lavatories have equally small slits, though in the form of small wooden sashes – presumably for more comfortable ventilation control. The three tall windows lighting the drawing room are folding casements, to allow the whole window to be opened up round the window seats.

There is much invention in the 'free' design of the windows according to their particular place and function, but none more so than in the circular windows containing leaded lights to the corridors. The large windows to the main stair follow the ascending form of the staircase. The secondary stair has a tall

narrow form expressing clearly its subsidiary function. There are no mouldings, no projecting sills. Window sills are of splayed bricks laid flush to the wall. Arches whether pointed or segmental are flat to the face of the wall, the severity of these details emphasizing the mass of the 18" thick walls.

Brilliant manipulation of internal volumes

If externally the house expresses its vernacular origins in its solid volumes, massive roof and the use of windows, doors and openings in a free expression of the function of the rooms behind them, then internally it is the brilliant manipulation of these volumes in spatial terms that demonstrates the relationships between different parts of the house under its sheltering roof. The roof itself does not constrain the spaces below it, but is designed to receive their penetrating volumes as expressively internally as it does externally.

The staircase as generator of the plan

Peter Blundell-Jones has described the plan of Red House as hierarchical, as indeed it is. Yet so subtly is it contrived in both plan and section that its overall unity of form, both internal and external, never seems forced or artificial. It is the staircase, of course, with its subtle 'movement' both horizontal and vertical, that controls the organization of the plan. This staircase is contained in a bold projection in the internal angle of the L-shaped plan, and links the galleries and

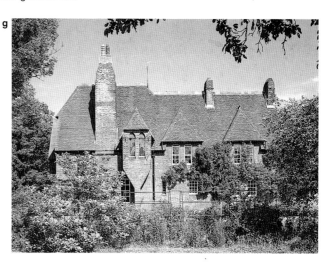

g

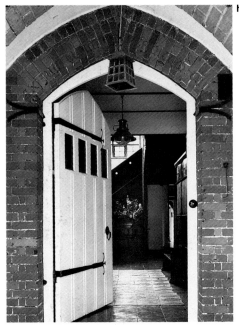

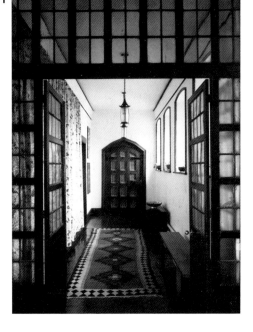

corridors which line the southern and eastern internal angles of the L, with the entrance hall.

These galleries and corridors therefore directly overlook the 'well-court' emphasizing – at least originally – its significance to the social and working life of the house.

The ground floor volumes

The entrance hall itself – entered through a massive door on the north facade, carried on wrought-iron strap hinges[h] – is literally the centre of the house.

To the left, entered through a glazed screen of antique glass in lead cames, is the gallery[i] which leads – via the Pilgrim's Rest porch – to the well-court and the garden. This gallery is lit by windows of painted glass quarries. Two of these windows have inserts of figurative panels representing 'Love' in a rich red tunic, and 'Fate' robed in green. Obviously later inserts, did they perhaps originally occupy two of the window panels in the front door, now containing modern abstract designs symbolizing 'The Four Seasons' in glass mosaic by Anthony Holloway? There is no firm evidence one way or the other.

To the right is the original dining room, now used (as by Morris) as a living room. It is entered alongside an elaborately decorated painted settle (yet to be restored at the time of writing)[j] with unfinished scenes from the Niebelungenlied* painted by Morris on the doors. This room is dominated by a huge red (Morris called the colour 'dragon's blood') lacquered dresser designed by Webb.[k]

But, seen from the hall, the most dramatic spatial effect is provided by the beautiful oak staircase straight ahead, with its vertical tapered newel posts, revealing the whole 'truth' of its construction, down to the glued blocks between treads and risers. In early morning with sunlight flooding through the whole circulation system of the house, the effect can be breathtaking and joyous. Above the staircase the sloping ceiling echoes the external roof form of the tower, carried on open roof trusses.[l] The ceiling is painted in bold geometrical and curvilinear patterns, which, like others in the house, were pricked out in the wet plaster to form a permanent guide to painting and repainting.

The first floor volumes

The character of all the upper floor spaces are dominated by the roof forms into which they penetrate, and within which the structure is clearly apparent.

The drawing room to the west of the staircase[m], representing the most important volume in the spatial hierarchy of the house, is the most lofty. It is lit by three tall casement windows from the north[c], and by the delightfully intimate oriel from the west.[g]

Like the dining room below, this room is also dominated by a major piece of furniture, a huge and massively detailed settle. Designed by Morris and built into his former studio at Red Lion Square, it was

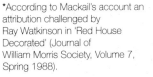

*According to Mackail's account an attribution challenged by Ray Watkinson in 'Red House Decorated' (Journal of William Morris Society, Volume 7, Spring 1988).

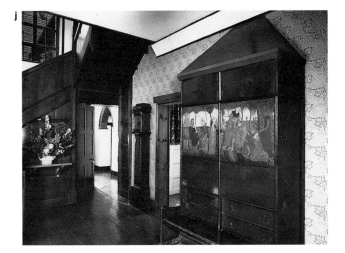

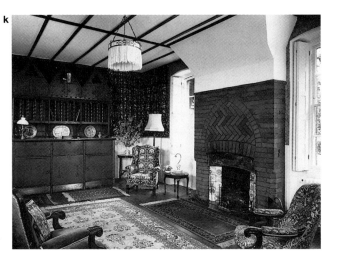

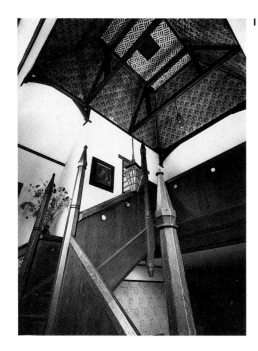

l

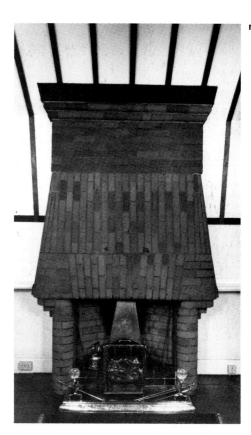

n

removed – with great difficulty – and transported to Red House. Philip Webb provided it with a platform/ canopy served by a ladder, so that it could provide access to the roof loft space – and also serve as a minstrels gallery. An extraordinary combination of functions, yet typical of Morris in providing a romantic twist to a practical requirement. The 'Salutation of Beatrice' was painted on the cupboard doors of this settle by Rossetti (the central door panel of which was the 'Dantis Amor', now in the Tate Gallery). A set of seven wall paintings by Burne-Jones was to have been the main decorative element in the room, the subject being that of the wedding of Sire Degravaunt – a medieval romance by Froissart. Only three panels were completed, the last of which portrays William and Jane Morris crowned with coronets in a scene representing the wedding banquet. But the major element in the room is undoubtedly the great brick chimney piece.[n] It dominates the room even more than those of the dining room and hall; terminating with an oak fascia at the intersection of the ceiling plane it carries the motto 'Ars longo Viata Brevis'. It is obviously Chaucerian in its reference – though Chaucer rendered it 'The life so short, the craft so long to learn'. Why did Morris use the Latin of Seneca, from whom Chaucer took it? Perhaps to emphasize its universal truth – after all Seneca got it from Hippocrates.

Being the largest room volume in Red House, this first floor drawing room is expressed externally by the highest roof ridge, and marked by the tall, dominant western chimney stack.[g]

Morris's first floor bedroom, on the north side alongside the drawing room, is also entered off the staircase landing under the steep internal pyramidal volume of the staircase tower.

Looking in the opposite direction, towards the 'inside' of the great L-shape of Red House, two exposed brick arches mark the approaches to the two wings – a segmental arch for the wider gallery of the northern wing; and a pointed arch for the narrower corridor of the western.

Why segmental and why pointed? The segmental arch of wide span[o] carries above it an internal lead lined channel draining the valley gutter between the major and minor roofs of the north wing; therefore a flattish arch form was most practical. The pointed arch[p] gives height to the opening of the narrower corridor of the west wing with maximum stability to the brickwork and roof of the south west corner of the stairtower. Both arches were, then, selected for their suitability for the purpose, but also to clearly identify their role in the hierarchy of the building's circulation.

At the end of the first floor gallery to the northern wing is Morris's studio (now the study), an L-shaped room with south-east corner windows overlooking the well-court and garden. The room is lit from high- and low-level windows on three sides, and extends upwards as a dramatic inversion of the roof volumes.

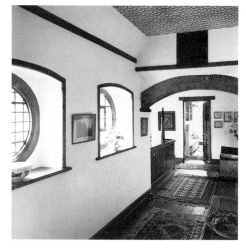

o

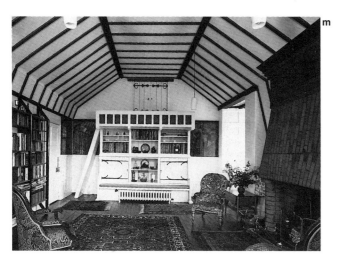

m

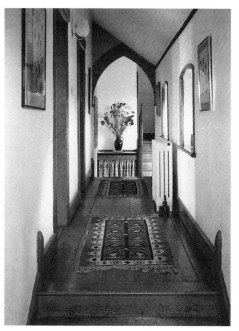

p

The rest of the upper west wing is taken up with bedrooms, a maids' dormitory lit by the great south facing dormer window, and housekeeper's room.

A beautifully lit and detailed secondary stair leads down to the working part of the house and kitchen (now the dining room) overlooking the bowling green. The adjoining scullery (now a kitchen) looks into the backyard with its stores and former laundry.

The historical significance of Red House

Today Red House is visited by more people than ever before. Why is this so and why is this small and modest building in a suburb on the edge of London sought out by architectural pilgrims from the four quarters of the world? What is it that Red House has to say to them?

To answer these questions it is helpful to look beyond the bricks and mortar, the shape of the windows and pitch of roof, important as these are, to try and understand the motives of its designers, what they were trying to say, and the influences that shaped their thinking.

In its conception, Red House is the expression of the romantic dreamer Morris, and in its execution, the sensitive yet practical builder/architect Webb. The house is full of artistic and architectural allusions, yet so subtly are they contrived that there is no mannered effect – no straining after self-expression, something utterly foreign to the whole attitude of both Morris and

Webb towards architecture. As Lethaby wrote, both were brilliantly imaginative designers 'restrained only by the fear of unmeaning expression'.

Ruskin and Pugin

The moral and philosophical influences of Ruskin and Pugin affected the thinking of both men, though in different ways and to different degrees.

For Morris 'the lesson which Ruskin teaches us is that art is the expression of pleasure in labour'; and with this he linked the idea of the creative freedom of the craftsman.

Webb did not go as far as Morris in accepting this doctrine. He believed it to be the task of the architect to design, and to direct craftsmen so as to obtain a 'consistent whole'; but he believed that in order to do this the architect had to have a deep understanding of the science and the craft of building. Lethaby wrote that Webb intended to see clear and straight – 'He had his eyes set on being rational and of his own time'. Not for him the ivory tower of the atelier, but the truly medieval role of the architect as master builder.

Street and Butterfield

Pugin's advocacy of architectural forms which aroused moral and emotional associations led him to favour 'Gothic' principles; but also an architecture in which 'there should be no features ... which are not necessary for convenience construction or propriety',

and the view that 'all ornament should consist of enrichment of essential construction'.

His views profoundly influenced Gothic revivalist architects such as Street, and Webb's training in Street's office developed against this background. From Street he also absorbed a strong sense of discipline in his work, as well as his determination to master the science and craft of building.

However, it was probably through Street that Webb became aware of Butterfield, whose work Webb undoubtedly admired. This is emphasized by notes in his sketch book of the older man's work – the only sketches of a contemporary practising architect he ever made, for he preferred to study historic examples. What first attracted Webb to Butterfield may have been the latter's reputation as a builder–architect. Butterfield certainly upheld Ruskin's dictum 'Do not be afraid of incongruities...do what is convenient'. Such empiricism strongly appealed to Webb.

Webb's search for a 'free' style

When one looks at the secular work of Butterfield in parsonages such as those of Coalpit Heath and West Lavington, these buildings, though built in stone, have a flavour that from the standpoint of Red House is unmistakable. This is even more evident in the brick cottages at Braunstone, which have shallow hipped roofs rising above windows whose heads break through the eaves of the steeply pitched roof, and at Baldersby where the composition is of clustered roofs and hipped gables. There are traces of these forms in Red House. But it was the vernacular character of these secular buildings that was most influential in the development of Webb's 'free' style*, which eschewed historicism, seeking rather an architecture of common sense, using tradition with invention.

Fundamental honesty of style

Common sense – tradition – invention: these are the principles which in their different ways Morris and Webb shared in their search for a fundamental honesty of style.

Neither of them had any time for pomp and ceremony, and their common delight in every-day things was reflected in their belief in an architecture both beautiful and homely. It was this very quality that Nicholaus Pevsner observed in his Pioneers of Modern Design (1936), when making a significant reference to the character of Webb's work as epitomized in the design of Red House. 'The architect' he says 'does not imitate palaces' and the house (is) 'solid and gracious looking, but not in the least pretentious'.

This was how many young architects and students in the 1930s – committed disciples of the 'modern movement' – saw it, and in this shared with Webb and Morris the firm belief that a house, or a school, a factory or a barn, were as important as a church, a palace or a town hall.

*First recognized by Muthesius in 1904, in his massively influential study 'Das Englishe Haus', as the break with the 'pastiches' of the Classical and the Gothic revival.

The appeal of Red House today

Perhaps the reasons for Red House's appeal today, lie in a renewed attraction towards three principles it epitomized at the time it was built – a reaction against pretension and overweening exhibitionism; a reaction against industrial ugliness; and a reaction against industrial inhumanity.

Red House embodied these values because they were the values of its creators, Morris and Webb. Lacking rhetoric or exhibitionism, it relies on such virtues as modesty, directness of expression and humanity to convey its aesthetic meaning. It moves away from the 'battle of the styles', towards a freer design which pays more attention to utility, materials, and other purely practical considerations. It escapes from the industrial ugliness and inhumanity of the 19th century by drawing on vernacular building traditions which were still alive in the smaller towns and villages of England. It aspires to an architecture of beauty, for the common man.

These values have a renewed attraction for the inhabitants of the tense, frenetic and often dehumanized world of the late 20th century.

The utopian idealism of William Morris, now enjoying an even more popular and widely based understanding, can be sensed anew, through the medium of this remarkable yet modest building at Bexleyheath.

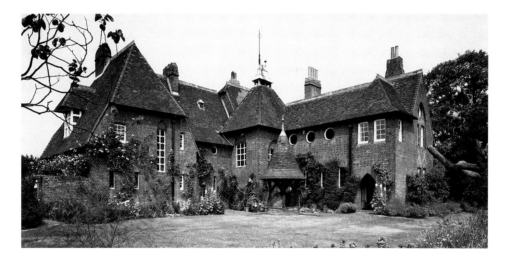

1853 William Morris enters Oxford University and meets Edward Burne-Jones.

1856 Morris visits cathedrals of Northern France with his friends William Fulford and Edward Burne-Jones.

1856 Morris takes up architecture, is articled to George Edmund Street, and meets Philip Webb.

1857 Morris takes up painting, tutored by Rossetti and shares studio at Red Lion Square with Burne-Jones.

1857 Morris takes part in the decoration of the Oxford Union, Rossetti introduces him to Jane Burden.

1858 Morris, Webb and Charles Faulkner row down the Seine – Morris discusses with Webb the building of a house for himself.

1858 Philip Webb leaves Street and 'sets up' on his own.

1858 The site for Red House at Upton, Bexleyheath, decided on in the autumn.

1859 William Morris marries Jane Burden in April.

1859 Construction of Red House started in the summer.

1860 William and Jane Morris move into Red House at the end of the summer.

1860/64 Laying out the garden and decorating Red House.

1861 Establishment of Morris, Marshall and Faulkner & Co.

1864 Philip Webb designs proposed extension to Red House for Burne-Jones and his wife.

1864 The plan for a joint establishment dropped and the Burne-Jones's move to Kensington.

1865 In late November the Morris's leave Red House.

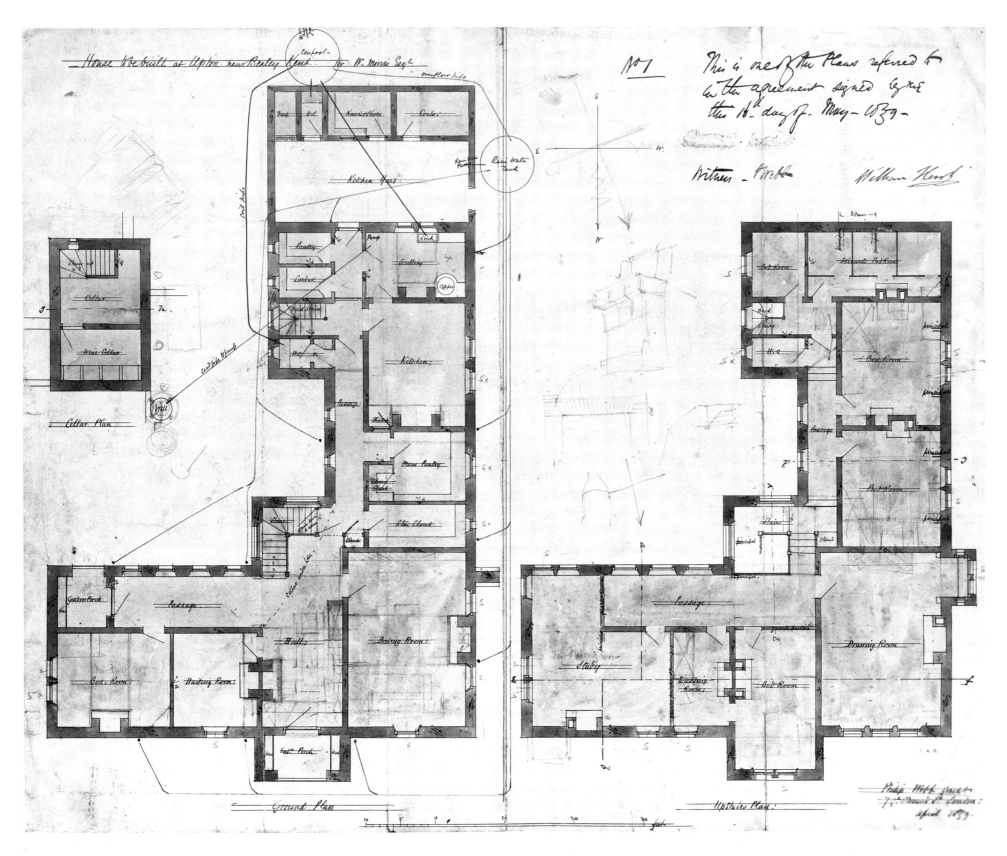

Webb's original ground and first floor plans, signed as contract documents in May 1859.

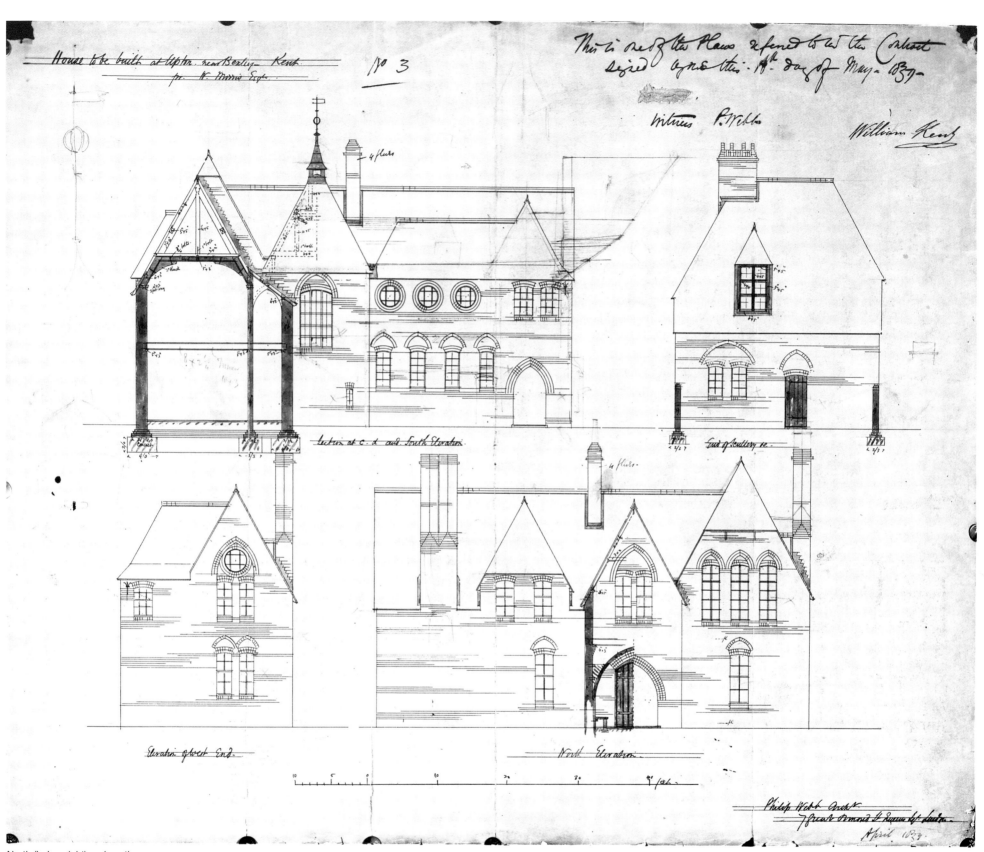

House to be built at Upton, near Bexley, Kent
pr. W. Morris Esqr.

No 3

This is one of the Plans referred to in the Contract signed by me this 18th day of May 1859.

Witness P. Webb

William Morris

4 flues

Section at c.d and South Elevation.

End of Scullery &c.

4 flues

Elevation of West End.

North Elevation.

Philip Webb Archt
7 Great Ormond St. Queen Sq. London.
April 1859.

North (below right) and south (above left) sectional elevations. In the latter, the section cuts through the west bedroom wing, along the line faintly discernable as c-d (looking downward) on the first floor plan, previous page. It shows a symmetrical 60 degree pitched roof over the bedrooms, extended to a shallower monopitch over the passage.

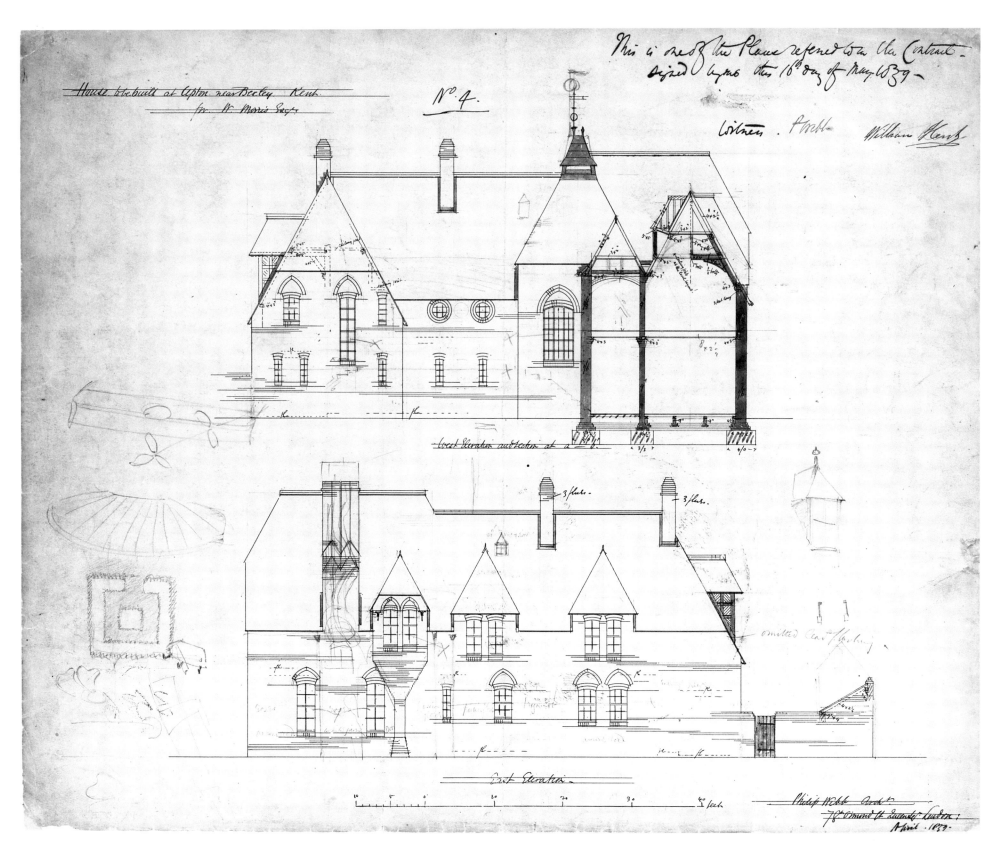

House to be built at Upton near Bexley, Kent.
for W. Morris Esqr.

Nº 4.

This is one of the Plans referred to in the Contract.
Signed by me this 16th day of May 1859 —

Witness. P. Webb

William Morris

West Elevation and section at a

East Elevation

Philip Webb Archt
7 Gt Ormond St Queens Sqr London:
April 1859 —

West elevation (below), and east sectional elevation (above), the latter along the cranked vertical line a-b on Webb's plans. Note that this major passage has its own separate double-pitched roof, partly exposed internally. At the far end of the passage is the segmental arch seen in **11**. The roof in the first floor study is exposed to a higher level than the passage, and can be seen in **15**.

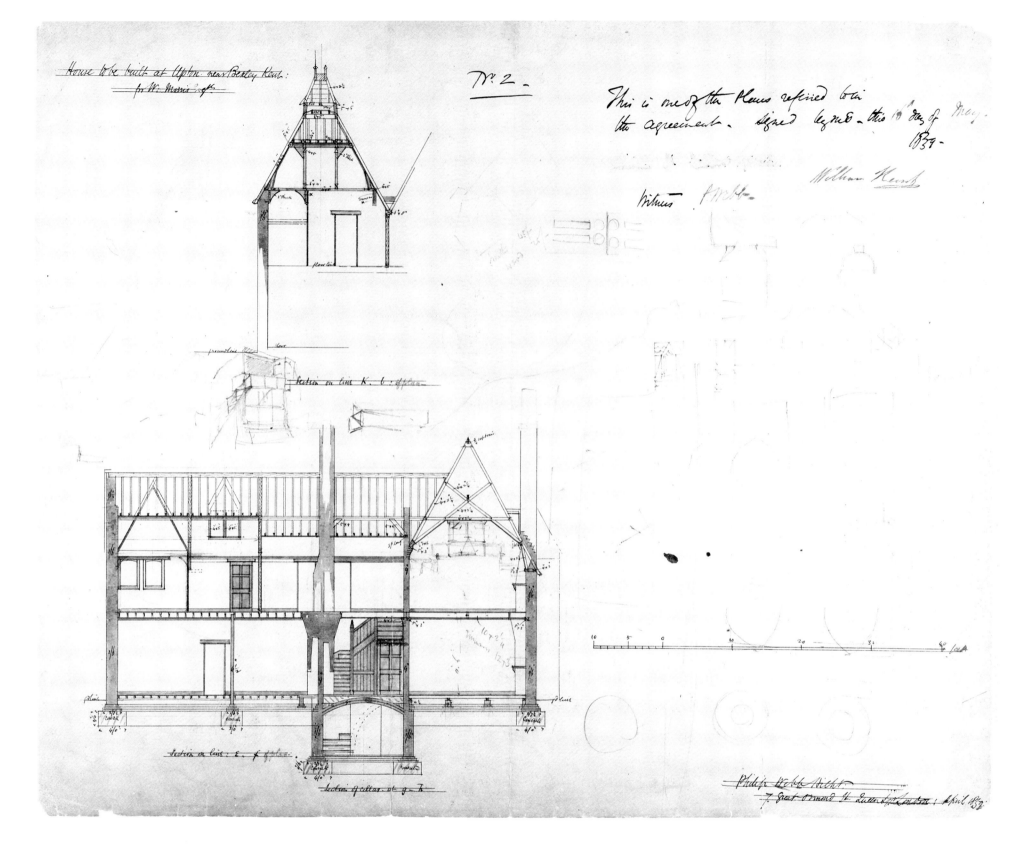

Longitudinal section through the north wing, along the horizontal line e-f on Webb's first floor plan. The drawing above that shows a cross section through the main stair (the vertical line k-l on the plan).

Entrance gate details, showing the satisfyingly simple and robust combination of brick piers, oaken posts and boards, and iron furniture. Note the hinges running across the full width of each gate, on both sides. The 'inside' of the gate, facing the garden, carries the exposed cross bracing.

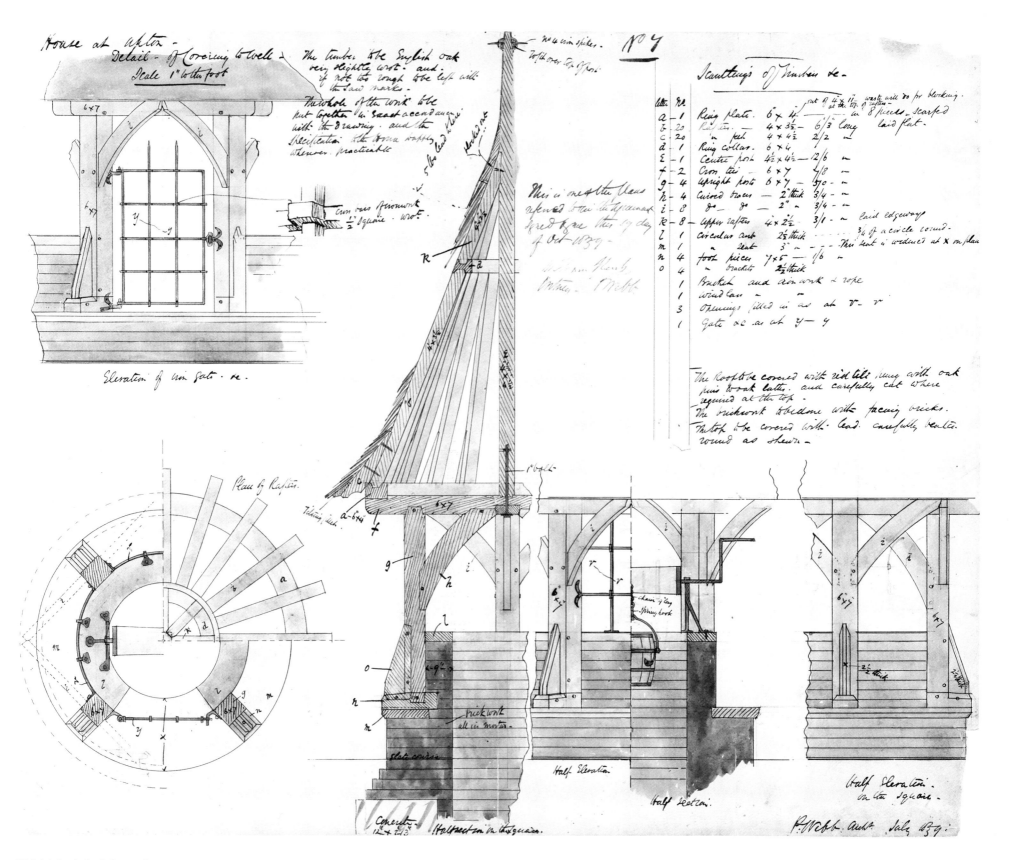

Well details. A sturdy frame of oak 'slightly wrot, and if not too rough, to be left with the saw marks'; plain red tiling; and at the top a lead-dressed timber finial.

Viewpoints of photographs

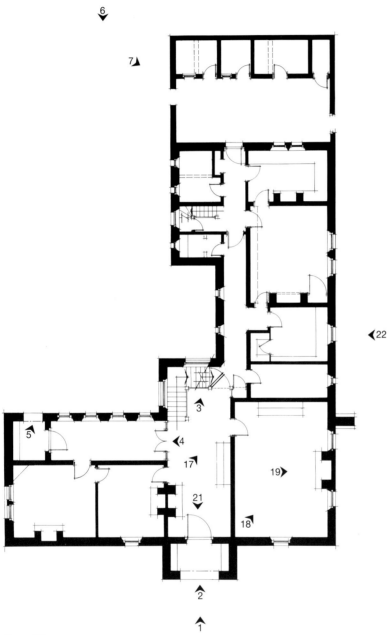

Ground floor

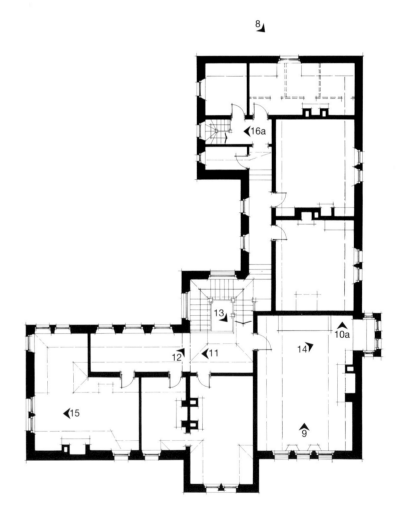

First floor

Photographs
Charlotte Wood

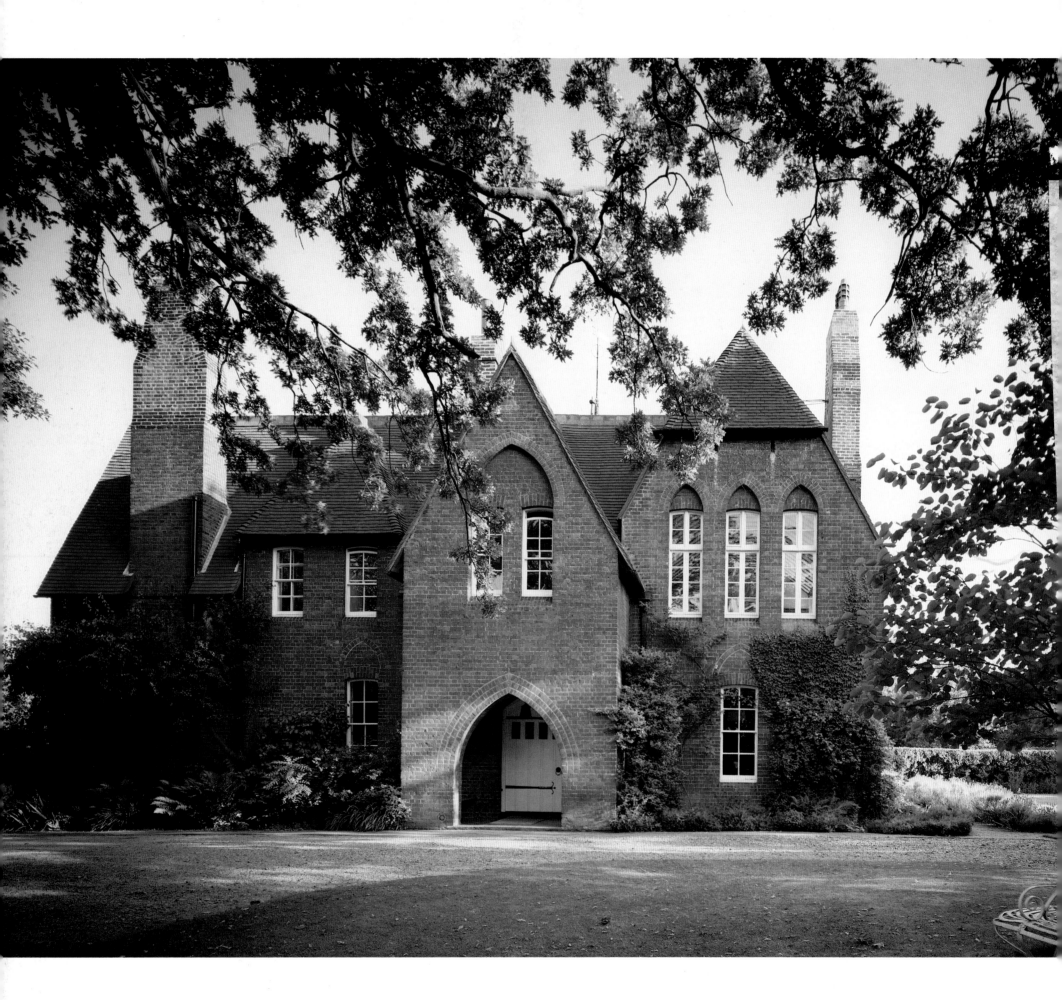

1 'The entrance boldly marked...'.

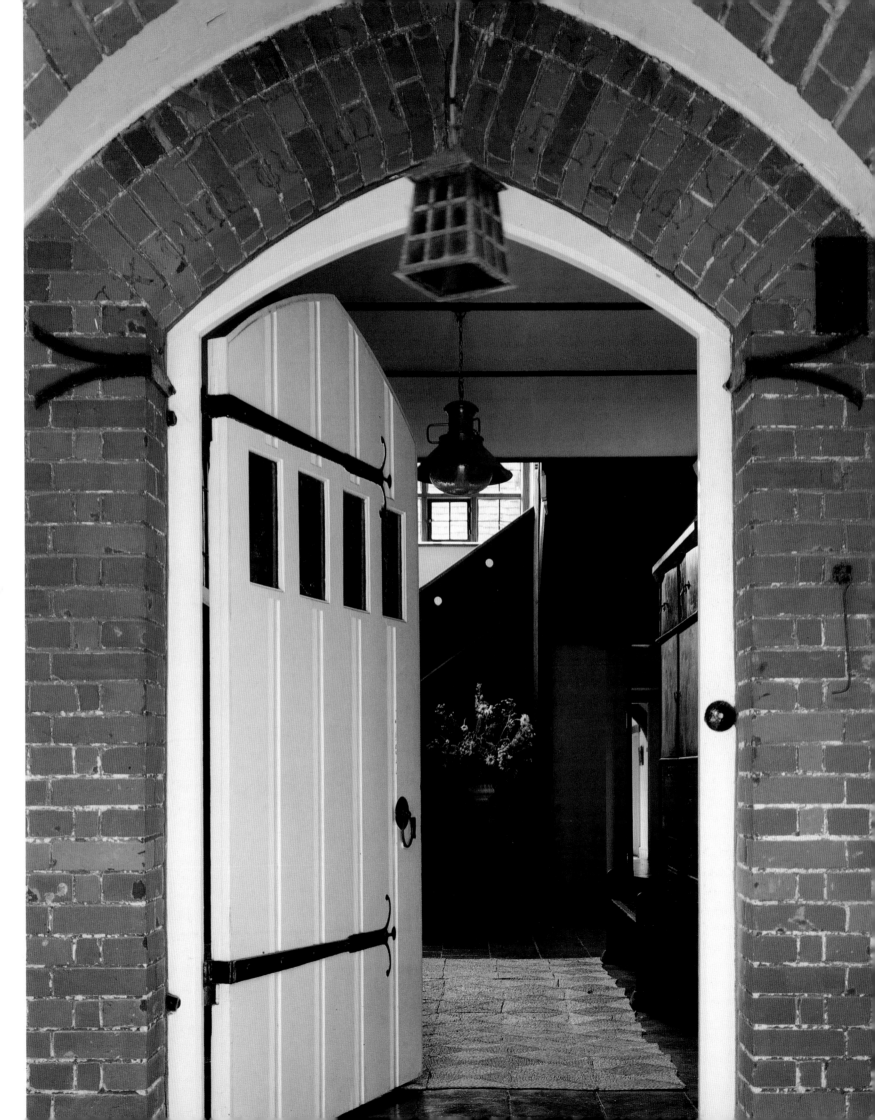

2 A massive door carried on wrought-iron strap hinges leads directly into the hall.

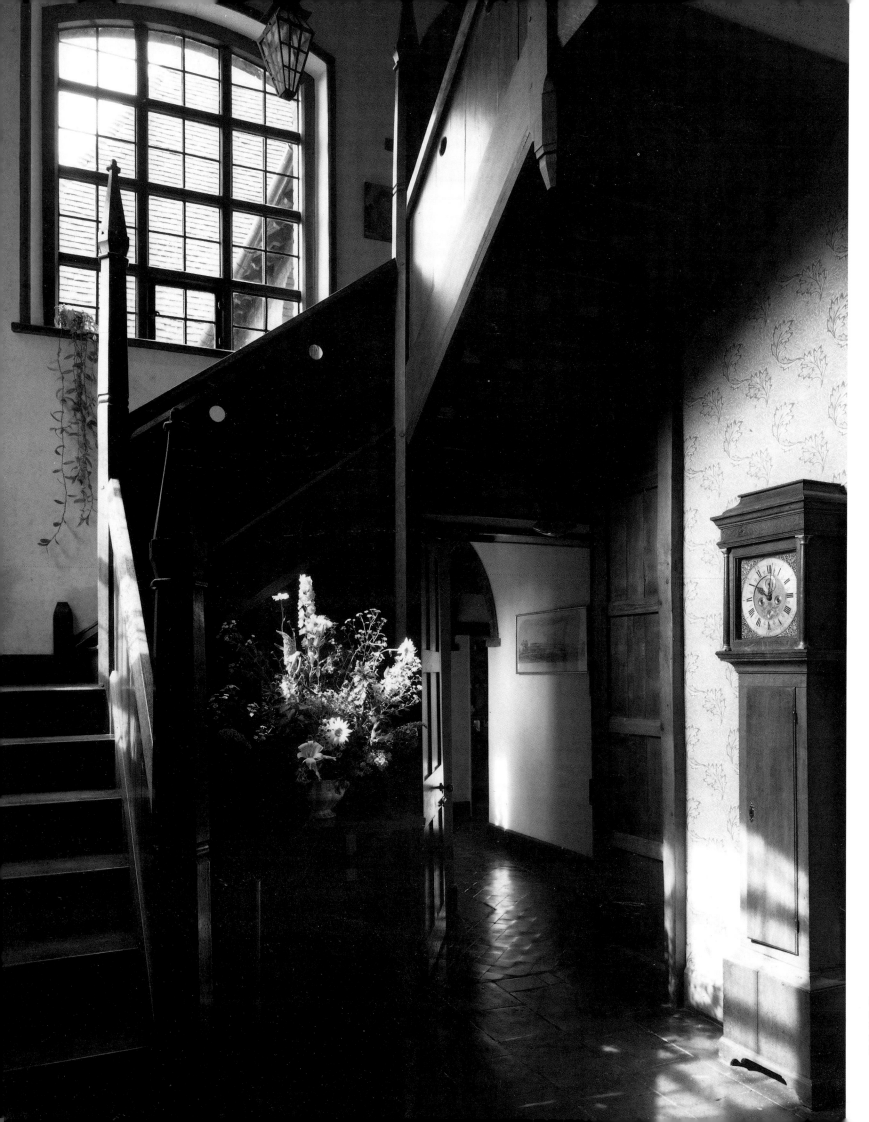

3 The oak staircase, a functional expression of vertical movement with carved newel posts, and with open treads and glued blocks exposed.

4 The gallery to the Pilgrim's Rest porch, seen through the antique glass screen. On the right are four windows, two of which have stained glass figurative panels portraying 'Love' and 'Fate'.

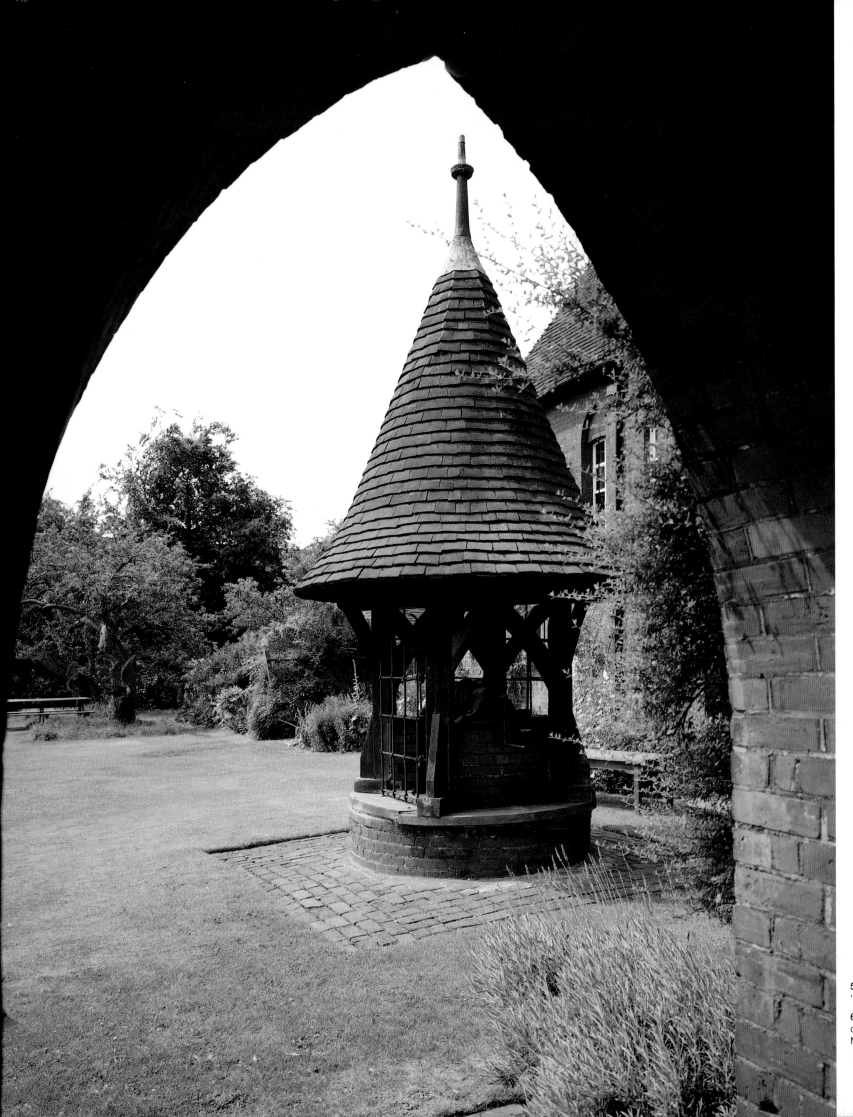

5 The well seen from the 'Pilgrim's Rest'.

6 The view back from beyond one of the original apple trees of Morris's orchard garden.

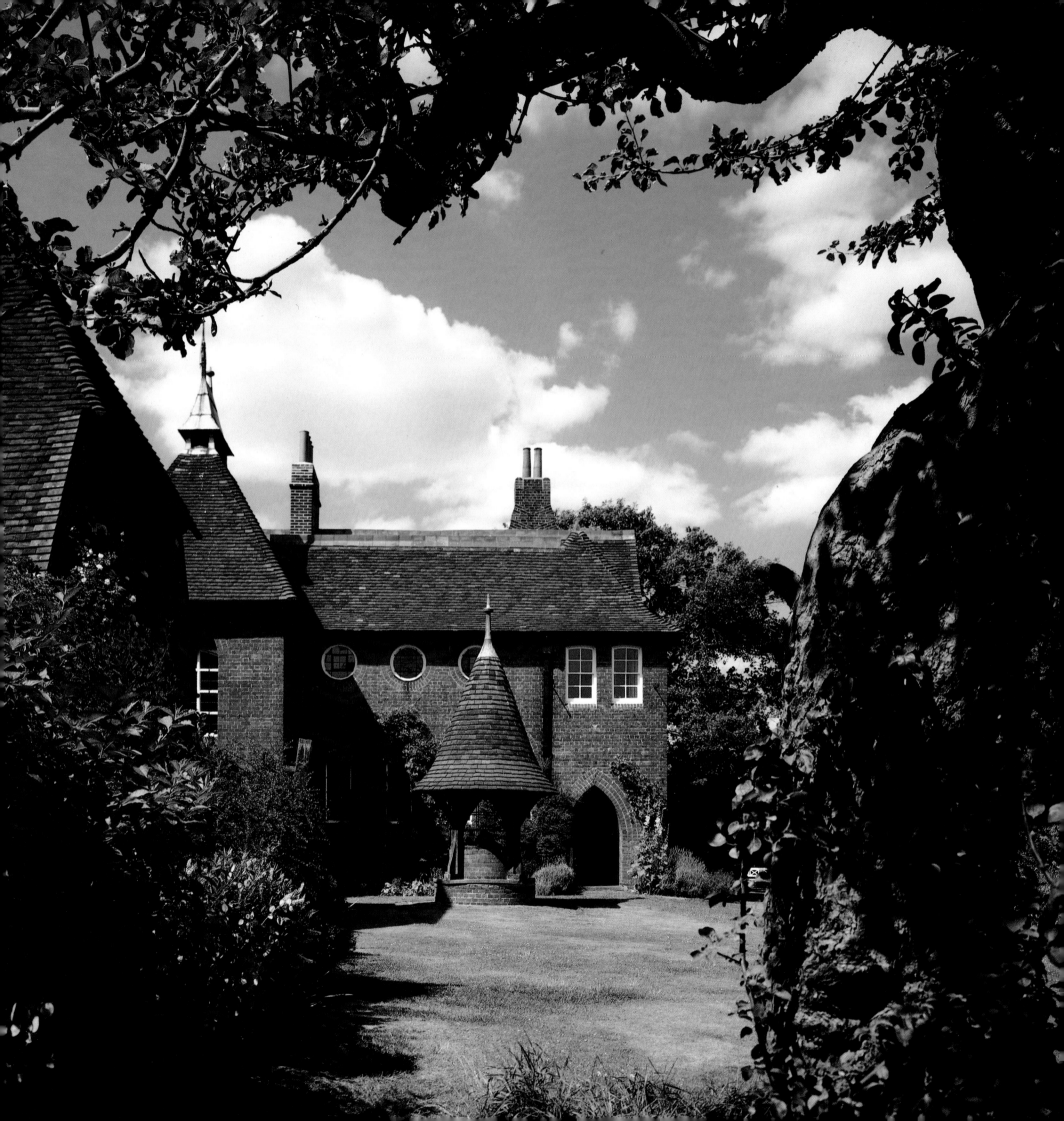

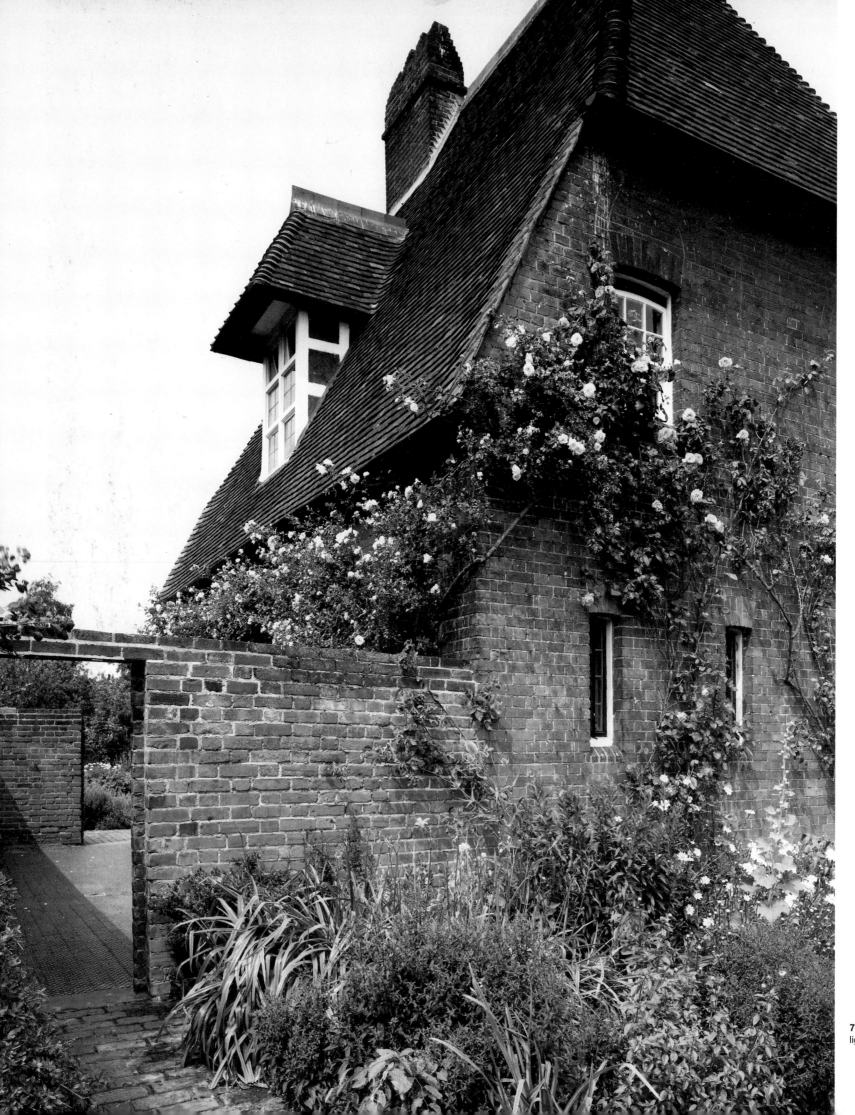

7,8 The great dormer window lighting the maids' dormitory.

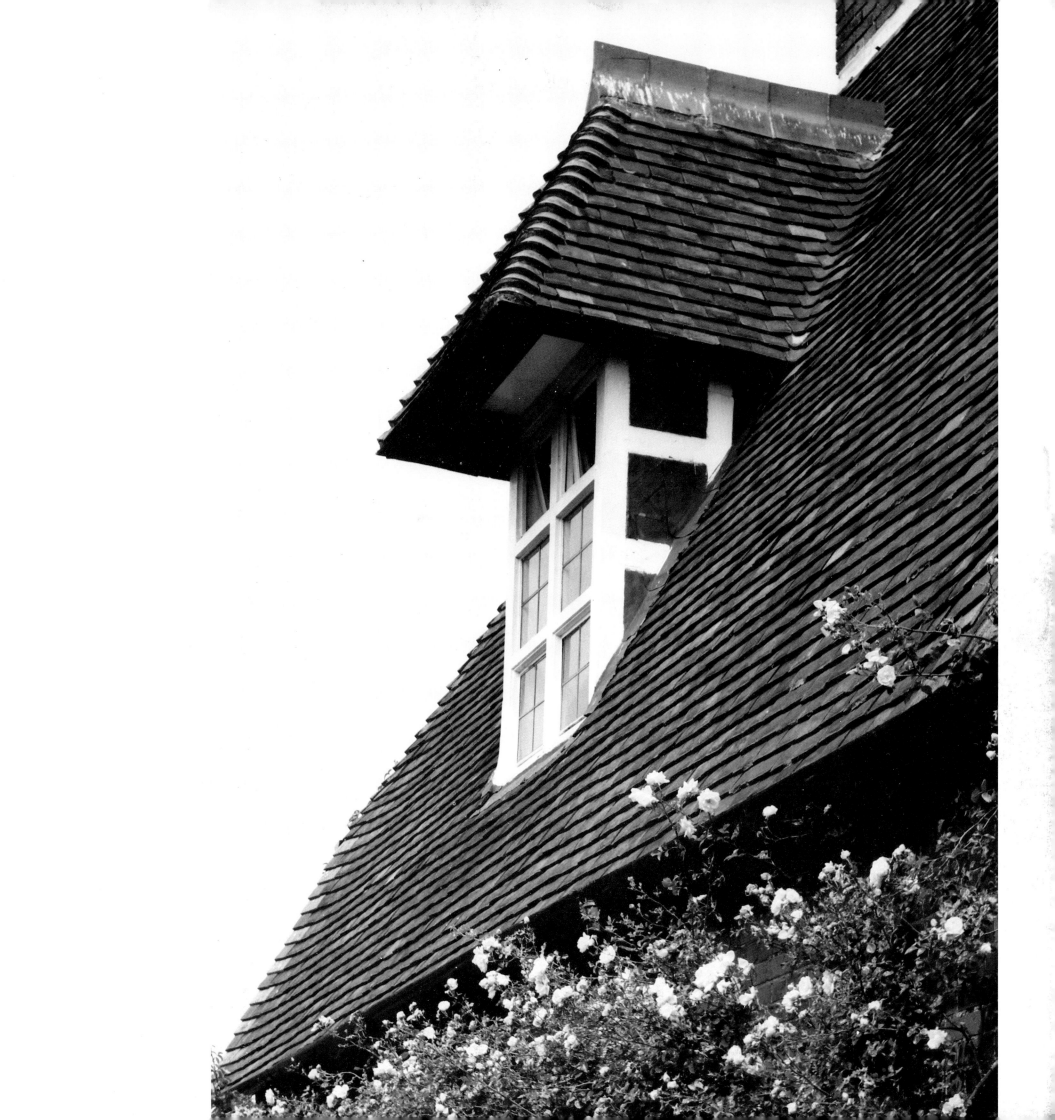

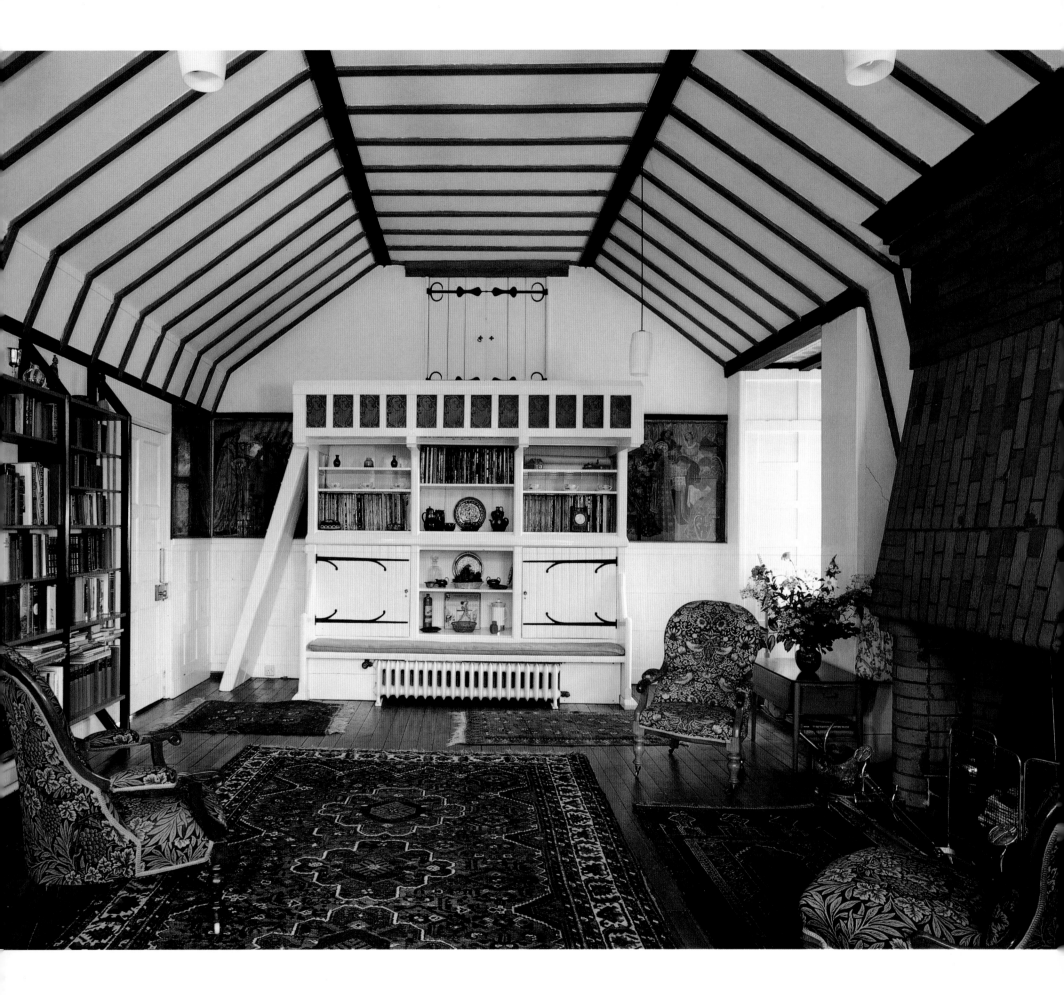

9 The first-floor drawing room, which Morris wished to be 'the most beautiful room in the world'.

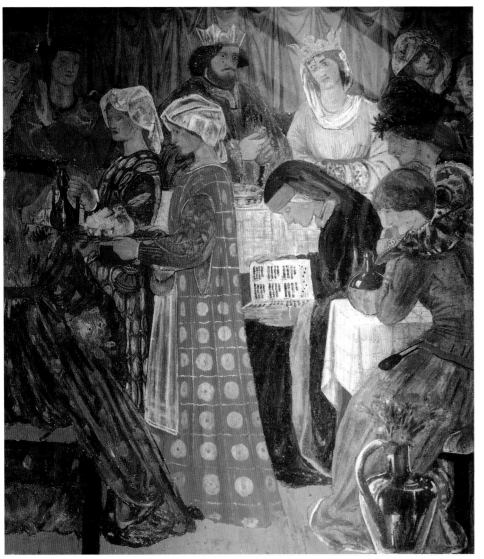

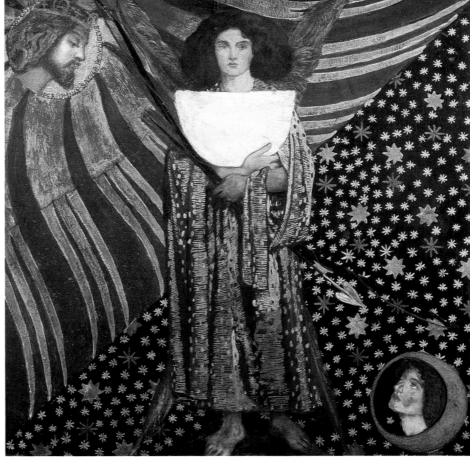

10 Above: On the right of the settle is Burne-Jones's wall painting of the wedding banquet from a romance from Froissart. Right: Rossetti's 'Dantis Amor', the original central door of the settle (now in the Tate Gallery, London).

11 The segmental arch leading to the north wing, its shallow form dictated by the need to carry a lead-lined gutter behind. As elsewhere throughout the house, Webb uses a pointed arch form as a structural relieving arch.

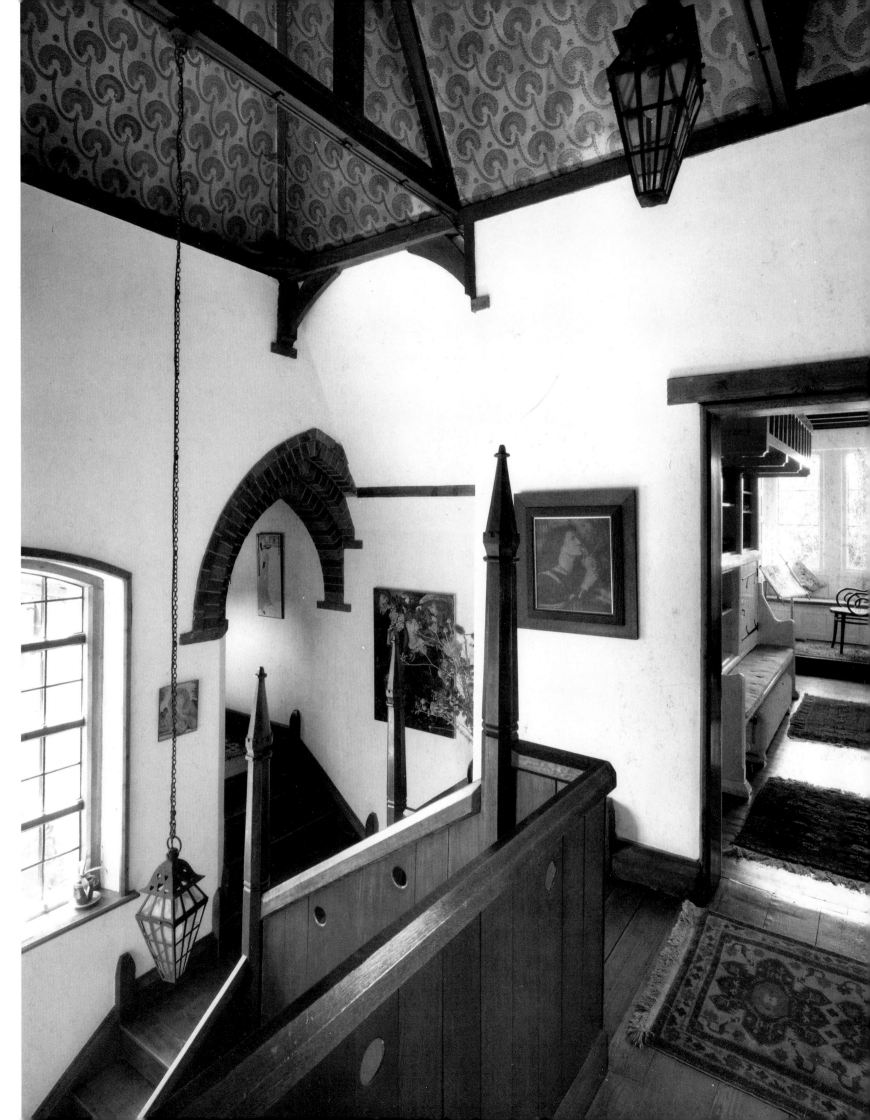

12 The pointed arch leading to the west wing corridor, seen from the upper landing of the main staircase.

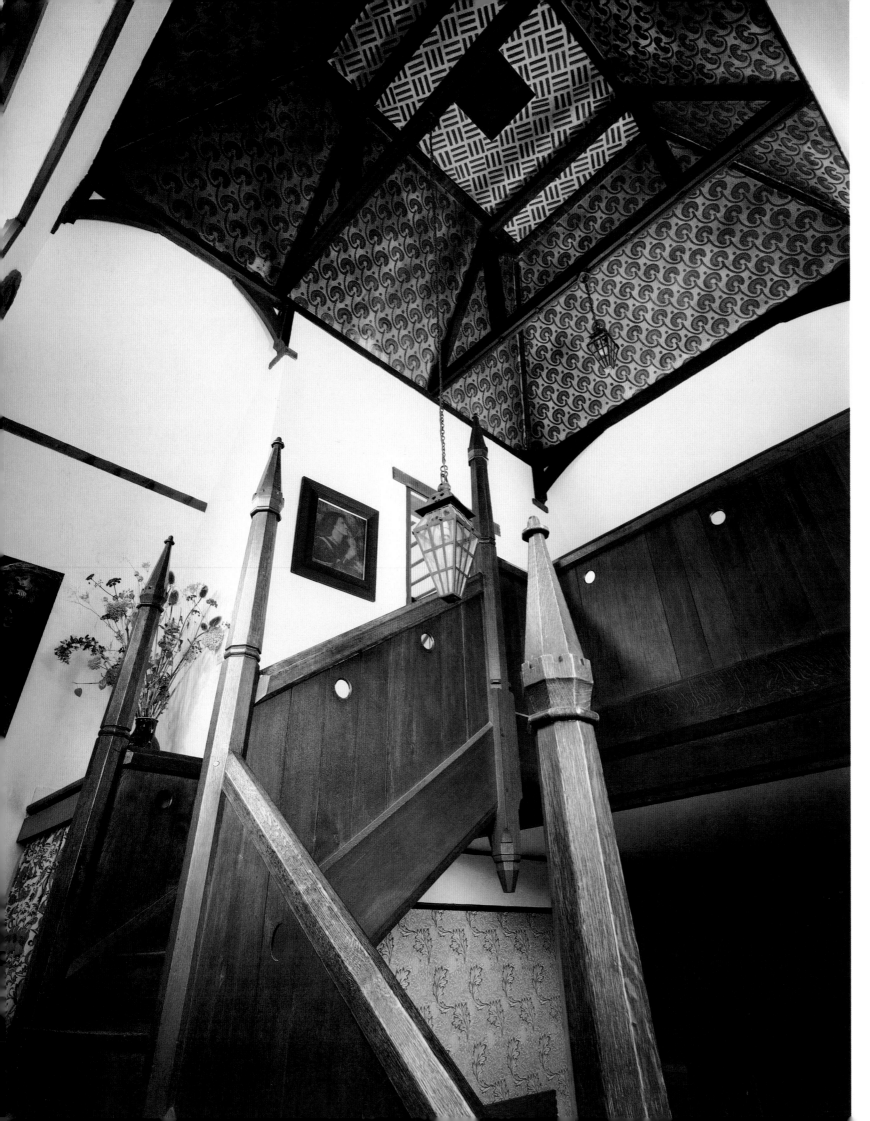

13 The dramatic spatial effect of the oak staircase, looking up to the painted pattern of the staircase turret ceiling.

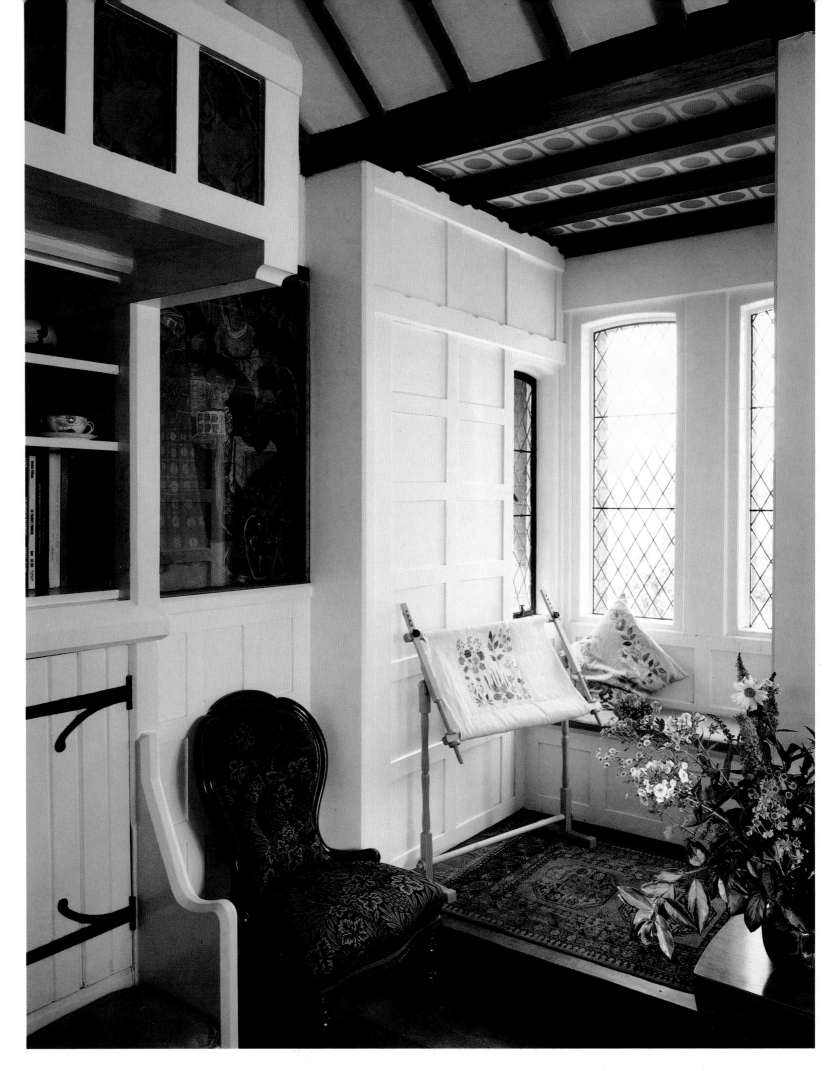

14 The oriel window within the drawing room on the first floor, where Jane Morris and her friends made embroidered decorations for Red House.

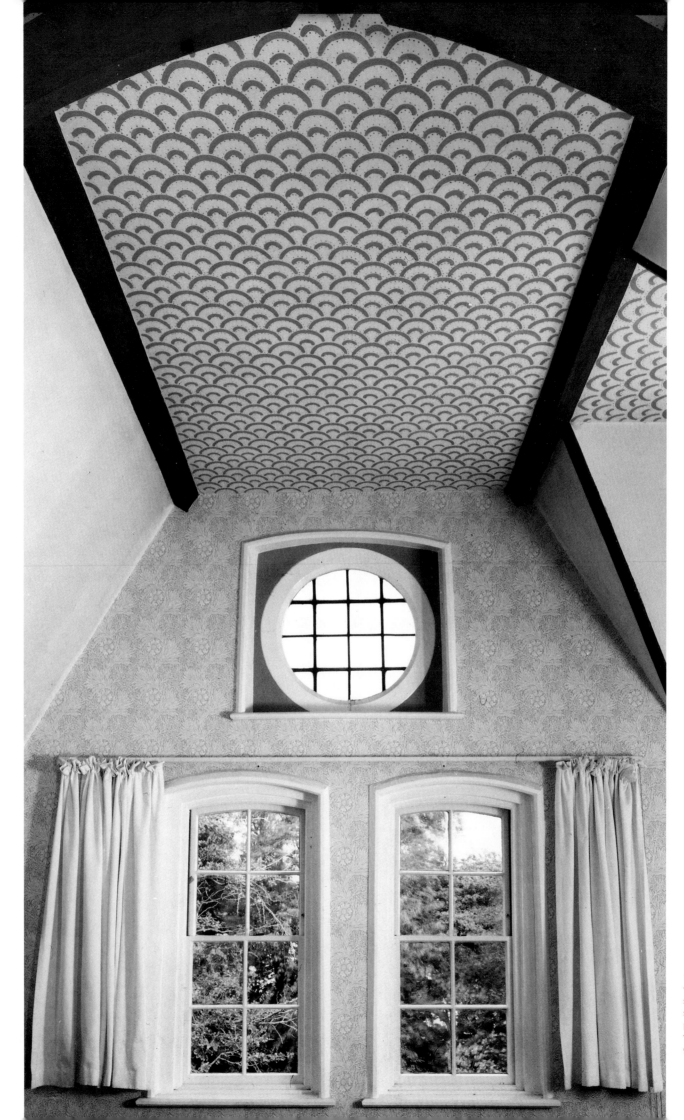

15 Morris's studio with its windows framed within the structural geometry of the roof, showing the original yellow ochre painted ceiling, its walls lined with the 'Larkspur' wallpaper in green.

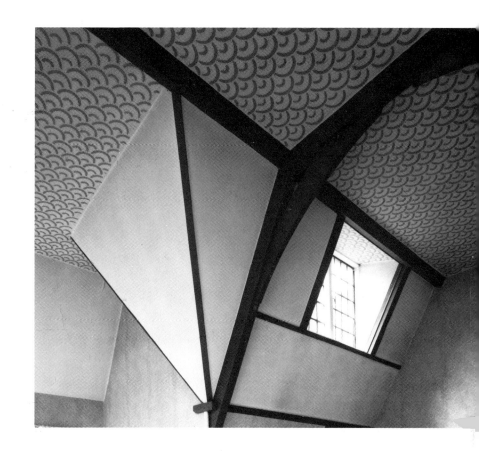

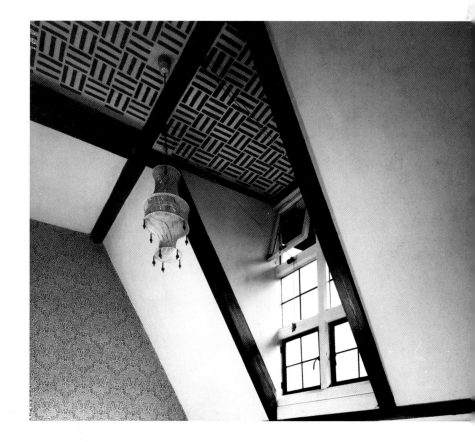

16 Above: The beautifully lit
servants' staircase.
Right: The geometry of the roof
deliberately expressed internally.

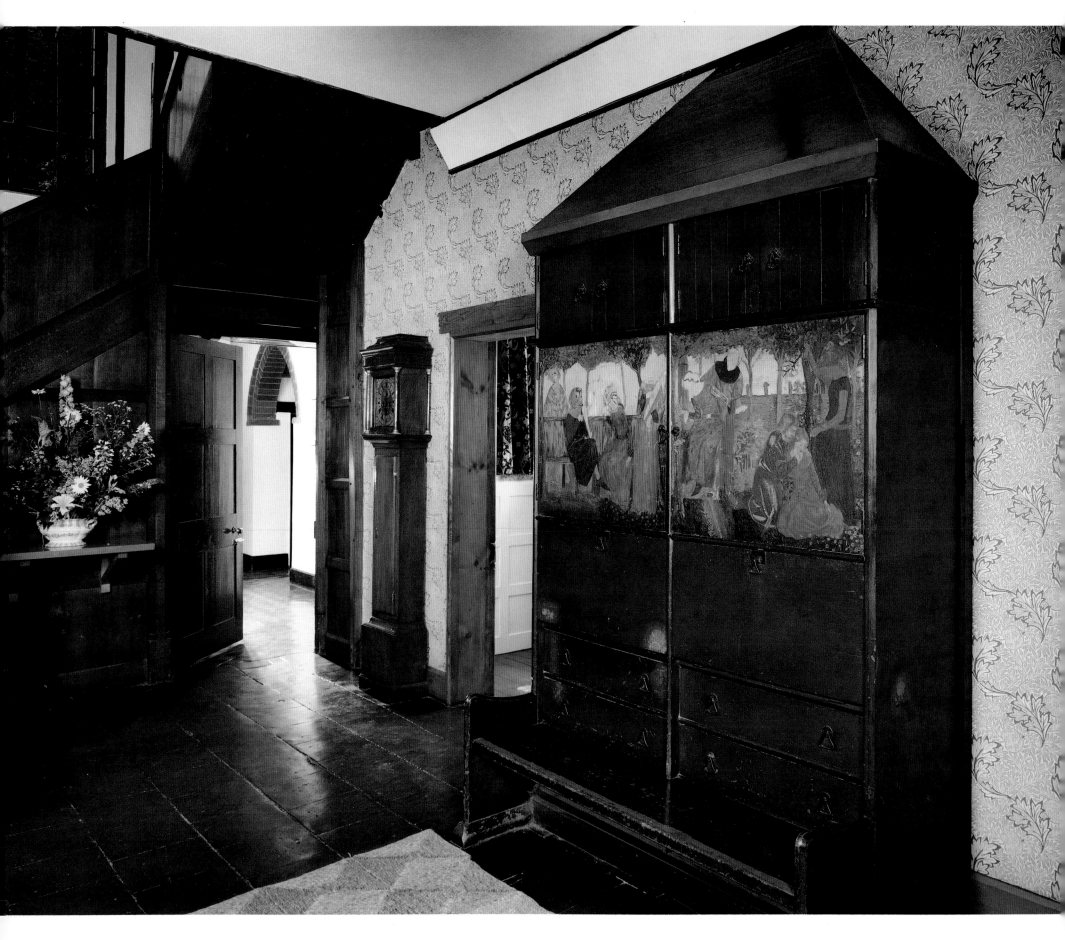

17 The settle in the hall with original decoration yet to be restored (it was over-painted in brown during the war), with unfinished 'Niebelungenlied' scenes painted by Morris.

18 The original dining room, now used as a living room, showing Webb's dresser (lacquered in Morris's 'dragon's blood').

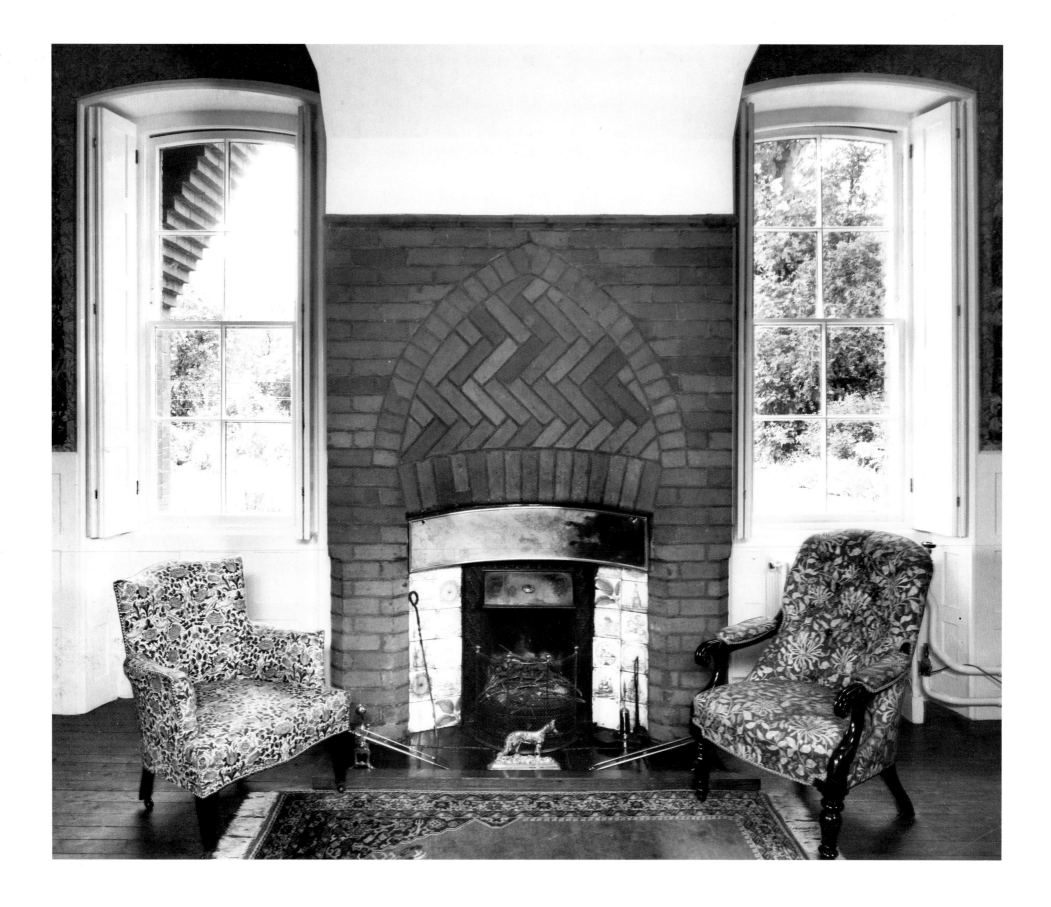

19 The exposed brick fireplace with Delft tiles seen in **18**, set between windows overlooking the orchard.

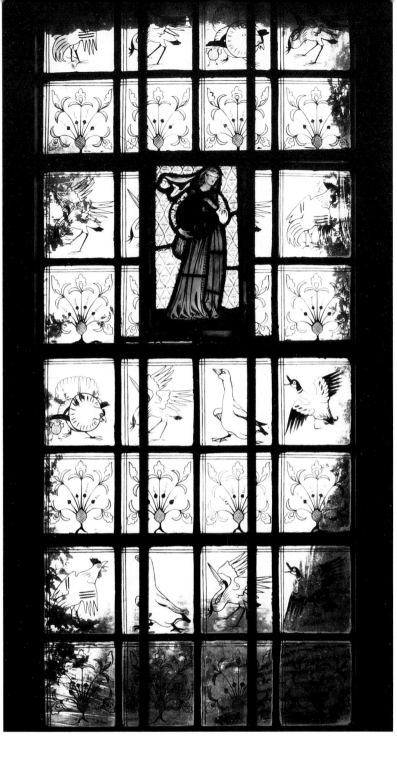

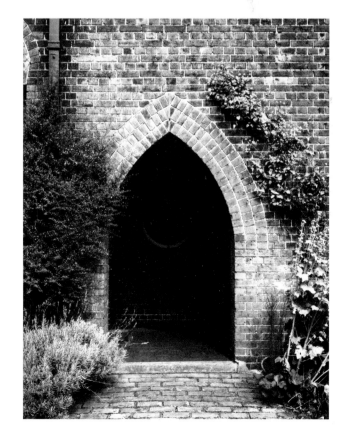

20 Above: Leaded glass windows in the ground-floor gallery seen in **4**, the quarries painted by Morris and Burne-Jones, with the central figure of 'Love in a rich red tunic' inserted at a later date.
Right: Beautifully crafted ironwork throughout the house is seen here on the door (top) to the 'Pilgrim's Rest' porch (below).

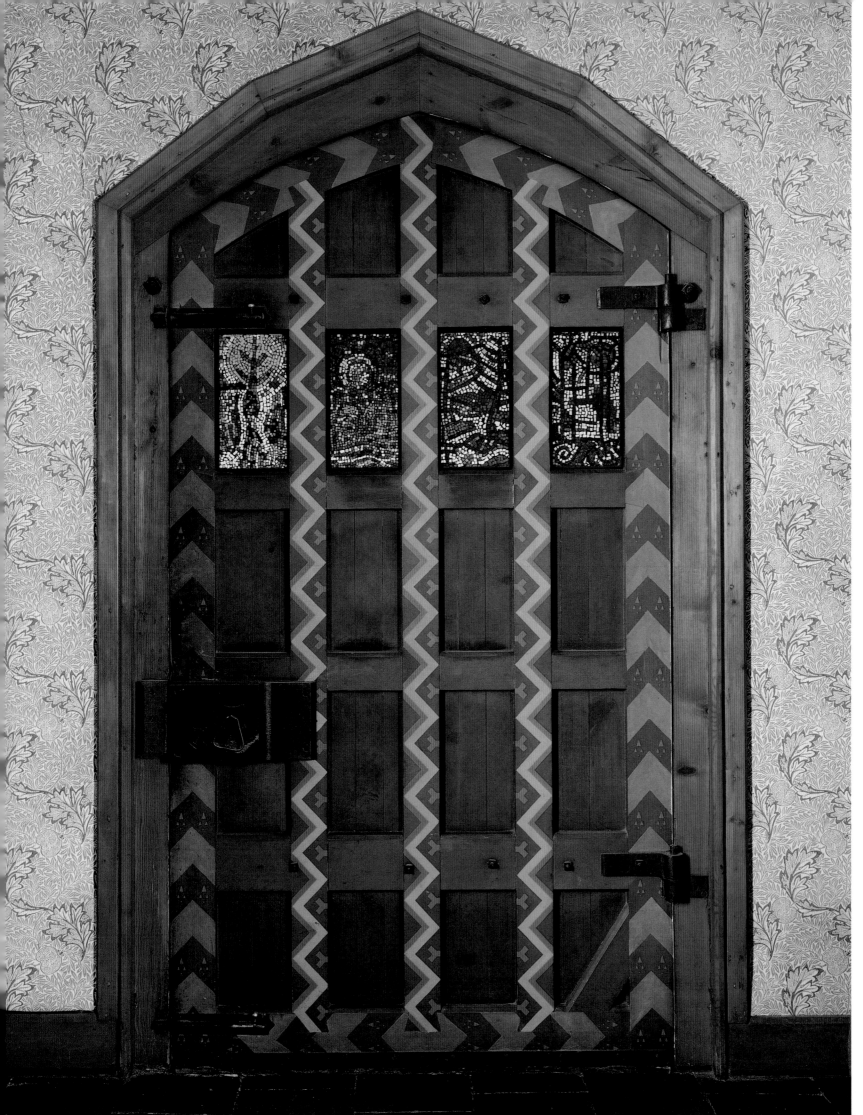

21 The entrance door seen from inside the hall, showing the bold geometry of Morris's painted decoration, with modern windows on the theme of 'the seasons' by Tony Holloway.

22 The great barn-like roof dominates the house when seen from the orchard.

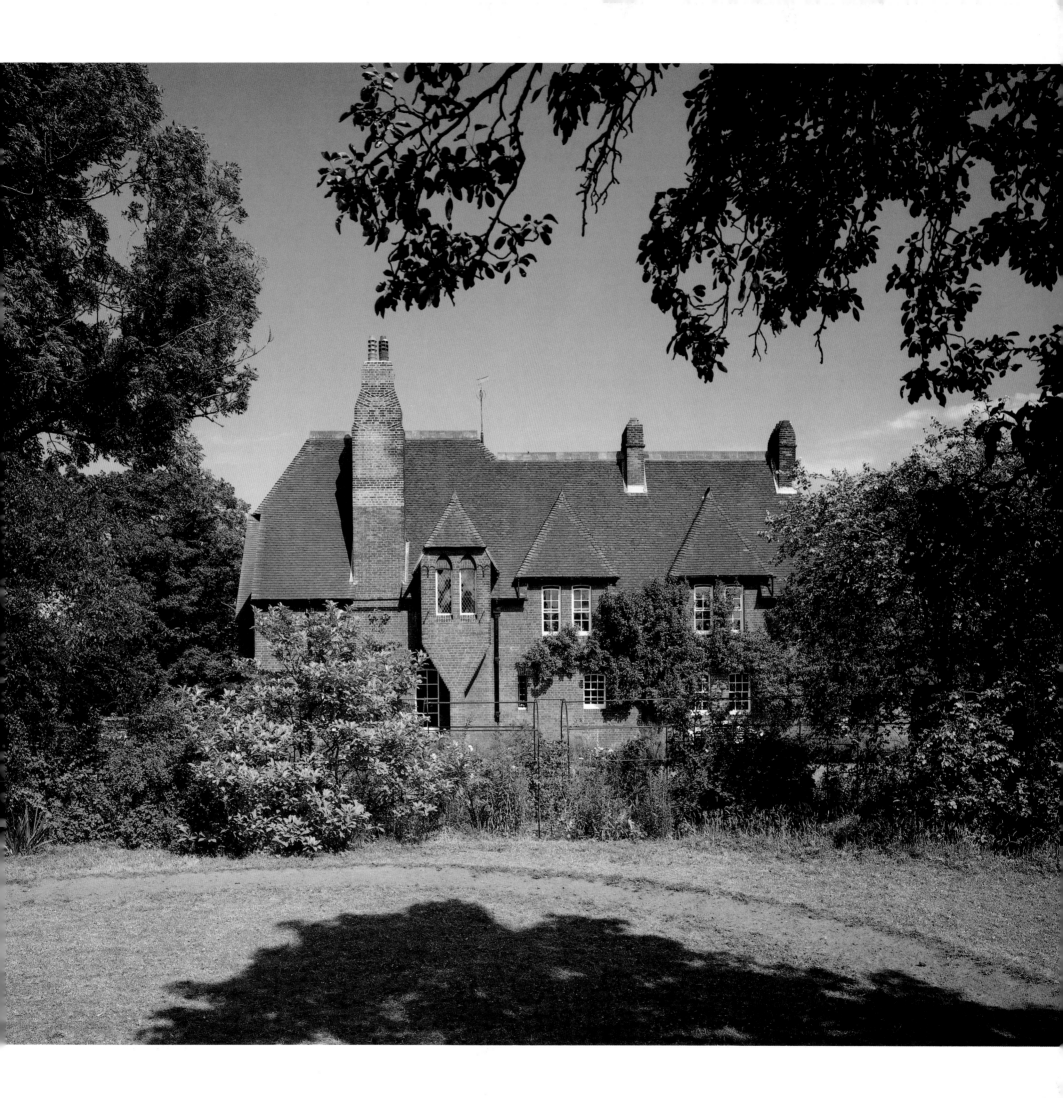

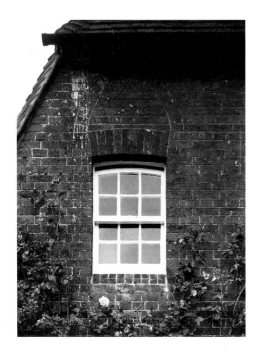

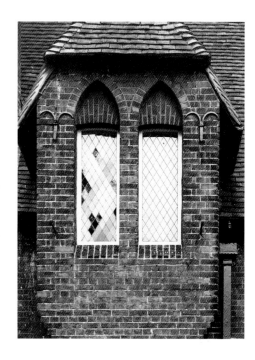

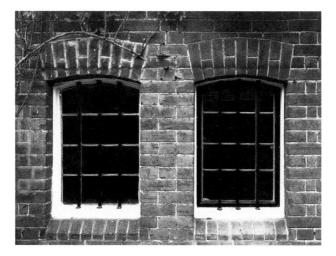

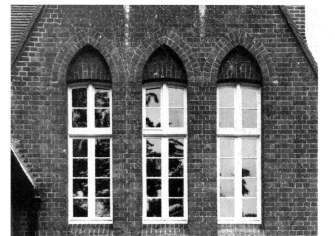

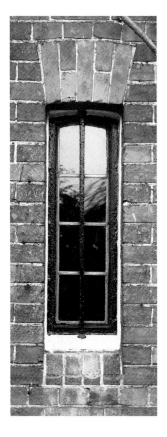

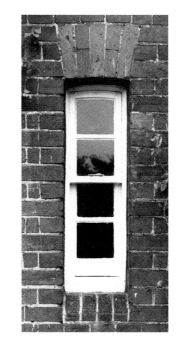

Drawings
Judith Copeman

Feet

0 5 10 15 20 25 30 35 40 45 50 55 60 65 70

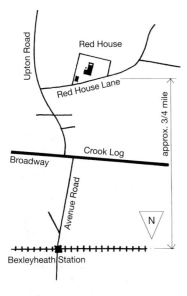

Location plan
Not to scale

1 Living room, former drawing
 room
2 Hall
3 Waiting room
4 Bedroom
5 Passage
6 Porch
7 Bathroom, former store
8 Kitchen/utility, former main pantry
9 Dining room, former kitchen
10 Kitchen, former scullery
11 Bathroom, former pantry and
 larder
12 WC
13 Kitchen yard
14 Store, former dustbin and WC
15 Workshop
16 Store, former coal store

Furniture
A Settle
B Sideboard
C Corner cabinet
D Settle

Basement plan

Ground floor plan
Scale 1:200

1 Drawing room
2 Bedroom
3 Dressing room
4 Study
5 Passage
6 Bedroom
7 Bedroom
8 Bedroom, former servants'
 bedrooms
9 Bedroom
10 WC

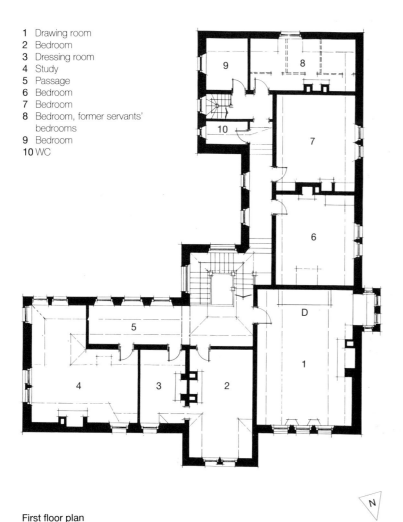

First floor plan
Scale 1:200

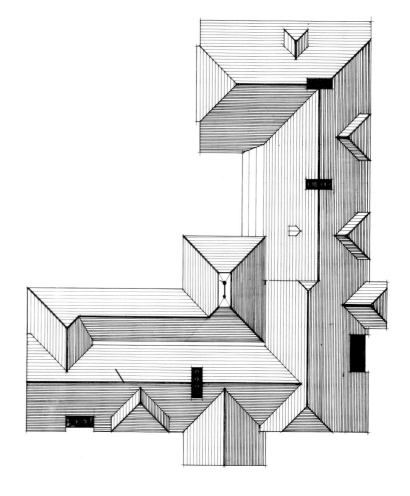

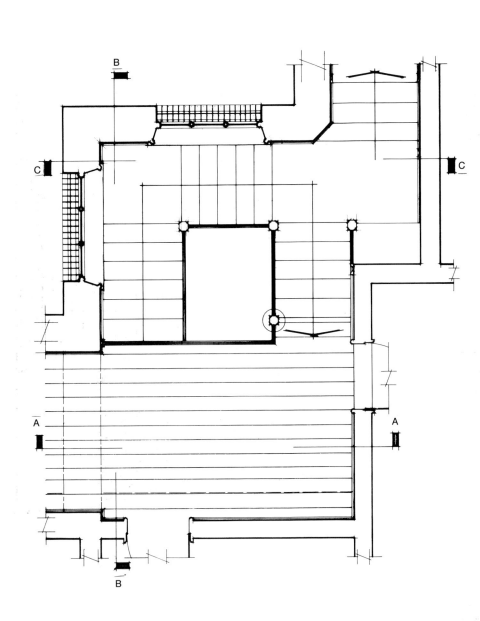

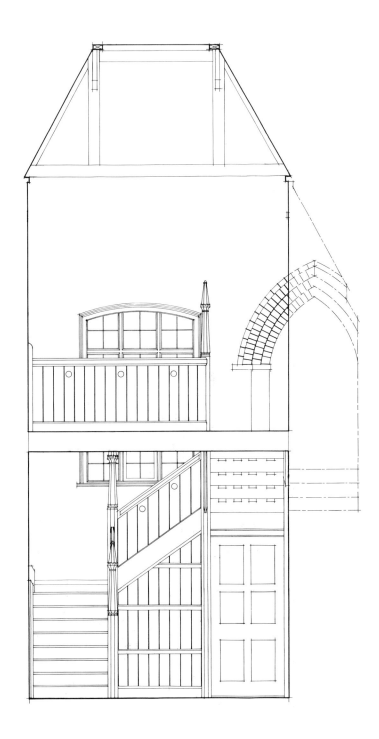

Plan of main stair
Scale 1:50

Section A

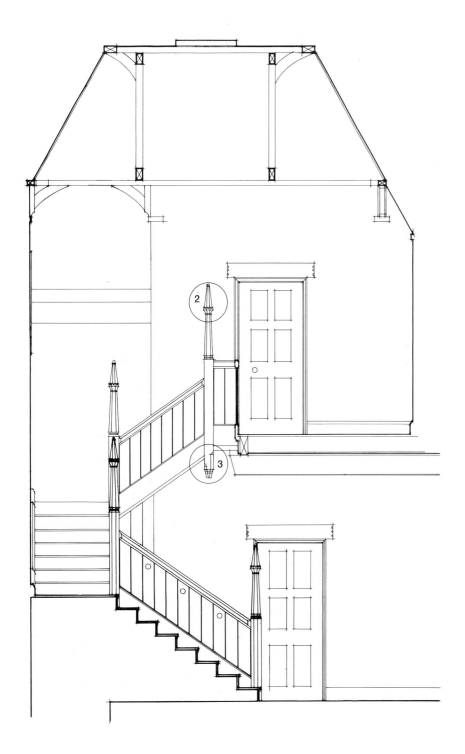

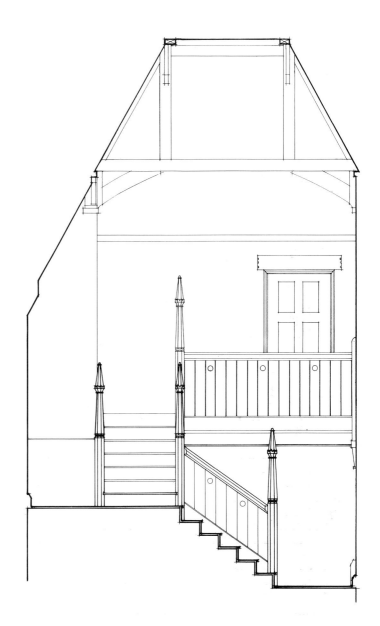

Section B
Scale 1:50

Section C

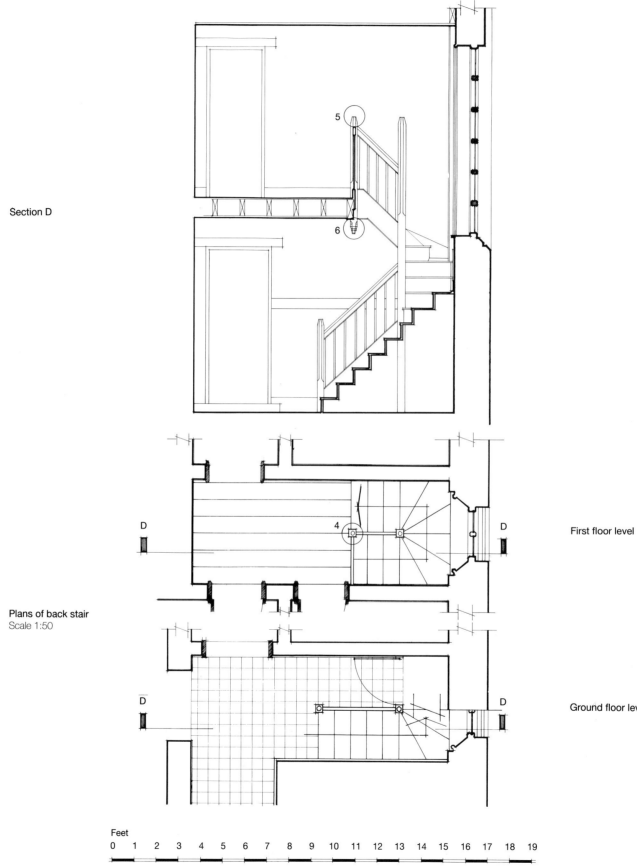

Section D

Plans of back stair
Scale 1:50

First floor level

Ground floor level

Feet
0 1 2 3 4 5 6 7 8 9 10 11 12 13 14 15 16 17 18 19

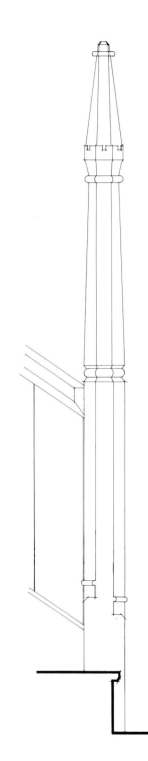

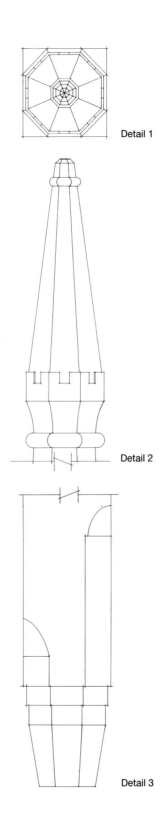

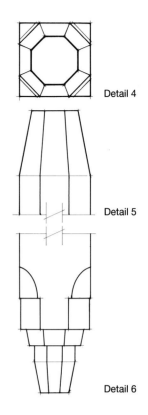

Detail 1

Detail 4

Detail 2

Detail 5

Detail 3

Detail 6

Newel Post
Scale 1:10

Newel post details
Scale 1:5

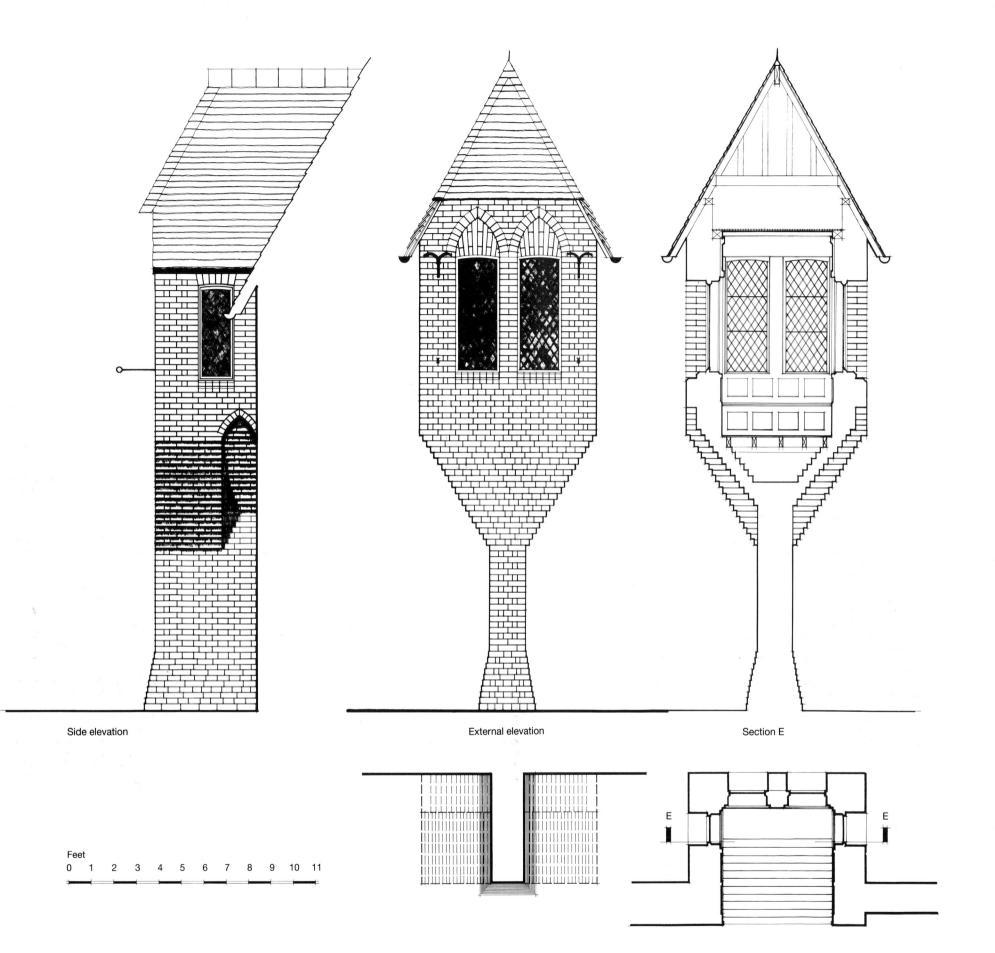

Side elevation

External elevation

Section E

Feet
0 1 2 3 4 5 6 7 8 9 10 11

Details of oriel window on west wall
Scale 1:50

Plan at support level

Plan at window level

Bibliography

1897 Aymer Vallance The Life and Work of William Morris, George Bell & Sons. Reprinted and published in 1986 by Studio Editions, a division of Bestseller Publications Ltd. Aymer Vallance was a personal friend of William Morris. In this, the first biography, is also the first published description of Red House, its value somewhat reduced in being based 'on notes of one' – unnamed, but probably Georgiana Burne-Jones – 'who used to know the house in the old days', rather than on first-hand observation.

1898 Laura Hain Friswell James Friswell – A Memoir, Redway. Describes the attitudes of the inhabitants of Bexleyheath to Red House and its 'artist' owner.

1899 J.W. Mackail The Life of William Morris, Longmans. Written by Burne-Jone's son-in-law, this was until recently the standard work on Morris, his life and work; and is probably still the best on the period leading up to and including the design and building of Red House, and the formation of 'the Firm'.

1902 'The House of the Idle Singer', Daily News, 21st November. Early recognition of the importance of the house – 'Now to be auctioned, Red House is a poem in bricks ... utterly devoid of trivial decorations'.

1904–5 Hermann Muthesius Das Englische Haus, Berlin. First English edition by Granada Publishing Ltd 1979. The first writer to acknowledge the special genius of Philip Webb and the crucial position of Red House in the development of the Arts and Crafts movement and domestic architecture in England.

1906 Nancy Vincent McClelland 'The Ideal Home of William Morris', Book News Monthly, 24th June. Contends that the building of Red House with its specially designed furnishings had a most profound effect on Morris's career as decorator and designer.

1933 Marjorie and C.H.B. Quenell A History of Everyday Things in England 1733–1942 – a revised 2nd (1938) edition published in 1942. A fascinating miscellany, with one of the best descriptions of Red House, with sketches of life there, including furniture designed by Webb and dimensioned sketches of Webb designs for table glass.

1935 W.R. Lethaby Philip Webb and his Work, 1st edition Oxford University Press. Re-published by Raven Oak Press 1979, with an extensive introduction by Godfrey Rubens. Originally published in serial form in The Builder during 1925 – a sketchy account of Webb's career but the only definitive one to date, including a description of the designing of Red House, and Webb's views on architecture and building.

1936 May Morris William Morris – artist–writer–socialist, Basil Blackwell, Oxford, 2 volumes. Volume 1 includes an account of Morris's attitude to the problems of decorating and furnishing Red House, and the establishment of Morris, Marshall, Faulkner & Co. May Morris was born in Red House but left it when she was only three years old. However, unlike most others who have written about it, she did visit the house, her signature along with many other distinguished visitors' etched on the glazed screen to the gallery.

1936 Nicholaus Pevsner Pioneers of the Modern Movement – from William Morris to Walter Gropius, 1st edition Faber & Faber, London; 2nd edition Museum of Modern Art, New York 1949; 3rd (Pelican) edition Penguin Books, Harmondsworth, entitled Pioneers of Modern Design. The classic work on the subject of the emergence of the 'Modern Movement' – 'he' (Philip Webb) 'takes the outside appearance of the house as an expression of inside requirements'.

1939 Lewis Mumford The Culture of Cities, Secker & Warburg, London. A work that was a major influence on students of Town Planning and Civic Design in the 1940s; includes reference to Morris, Webb and the significance of Red House. 'Here an attempt was made to go back to essentials ... every detail as straight-forward and sensible as in a 17th century English Farmhouse'.

1948 Ralph Dutton The English Interior 1500–1900, Batsford, London. Relates the decorating and furnishing of Red House to the aims of William Morris and 'the Firm' – Morris & Co.

1950 Philip Henderson The Letters of William Morris to his Family and Friends, Longmans, London. Includes the letter to Burne-Jones recognizing that they will never be able to create their dream 'Palace of Art' at Red House.

1953 Sir Hugh Casson 'Red House: The Home of William Morris', The Listener, October lst, BBC Home Service talk. 'It is one of those few buildings – like Compton Wyngates; or the Queen's House, Greenwich; or Coleshill – which are landmarks in the history of the English house and thus in the history of ourselves'.

1955 E.P. Thompson William Morris; Romantic to Revolutionary, Lawrence & Wishart, London. The most comprehensive study of the life and politics of Morris; contains a short description largely of the interior of Red House and the establishment of 'the Firm' including references to Walter Crane on the conflicting attitudes toward furnishing and interior design in the latter half of the 19th century.

1960 Mark Girouard 'Red House, Bexleyheath, Kent', Country Life, June 16th. Repeats Sir John Summerson's dismissal of its position as a pioneer building, justifying this because it 'made no stir in architectural circles at the time it was built' and was not 'illustrated in any of the architectural journals'. This is not surprisingly, as Webb never courted, or even allowed others to give publicity to his work. Poor photographs do not do the building justice.

1960 Jean Macdonald A Guide to Red House, William Morris Society. A brief history accompanies a room-by-room description and floor plans. Now out of print; a new guide is being prepared.

1966 R. Furneaux Jordan Victorian Architecture, Penguin Books, Harmondsworth. A classic, this book relates Victorian Architecture to its social background and the birth of modernity; it expresses a contrary view of the place of Red House as a landmark to Summerson and Girouard. 'It was not recognised as such in 1859 (that is the usual fate of any piece of progressive architecture) ... if we take everything into account ... the social as well as the architectural ... its significance was profound.'

1967 Philip Henderson William Morris, his Life, Work and Friends, Thames & Hudson, London. An excellent and readable biography, including a section on Red House and the decorative arts.

1969 John Newman The Buildings of England – West Kent and the Weald (ed. Nicholaus Pevsner), Penguin Books, Harmondsworth. A detailed description of Red House by a sensitive architectural historian, though the debt to Street and Butterfield is rather overdone.

1971 Paul Thomson William Butterfield, Routledge & Kegan Paul, London. A major work of scholarship on the work of the architect Webb most admired amongst his peers, including reference to his influence on Philip Webb whose studies of Butterfield's work appear in his sketch book.

1971 Virginia Surtees Dante Gabriel Rossetti, 1828–1882 – the painting and drawings. A catalogue Raisonné in two volumes, Clarendon Press, Oxford. Includes a description of 'Dantis Amor', the centre panel painting of the Drawing Room settle at Red House, with earlier studies for 'Dante and Beatrice in Paradise' and 'Salutation of Beatrice'.

1972 Richard Tames William Morris 1834–96, Shire Publications Ltd, Aylesbury, Lifelines Series No. 3. (Pocket biographies of individuals who influenced their own and subsequent generations.) Contains a lively description of Red House and the origins of 'the Firm'.

1975 Jack Lindsay William Morris, his Life and Work, Constable, London. The most penetrating study of Morris since Mackail's biography; contains a chapter on 'Marriage and Red House' and brings out the pyschological connections between Morris's poetry, his marriage, the building of and living at Red House.

1977 Jacques Midgeon 'Red House and Ruskin', Journal of William Morris Society, volume 3, Spring. Attributes Gothic porches, painted arches, steep roof and gables to Ruskin's 'lectures on Architecture and Painting 1854'.

1978 Christine Coleman and John Miller 'William Morris lived Here', Homes and Gardens magazine, February. A beautifully photographed tour of the house.

1980 Peter Davey Arts & Crafts Architecture – the Search for Earthly Paradise, Architectural Press Ltd, London. An account of the lives, theories and work of the architects of a movement which began in England, and had a major influence on the development of architecture in Scandinavia, Central Europe and America. Davey argues that current circumstances parallel the period that gave birth to the Arts and Crafts movement – alienation with the machine, and a questioning of basic tenets. It contains reference to the work of Philip Webb and the position of Red House.

1980 Lionel Lambourne Utopian Craftsmen – the Arts & Crafts Movement, from the Cotswolds to Chicago, Astragal Books, Architectural Press Ltd, London. Includes an illustration of Walter Crane's 'Tea at the Red House' (Fine Arts Society), which shows the well-court with the orchard trees still there, but no trellis round the court.

1981 Ray Watkinson 'Red House Revisited', Journal of Pre-Raphaelite Studies, May 1981. Red House is described as 'Morris's character in Webb's language'.

1981 Emmeline Leary 'The Red House Figure Embroideries', Apollo, 113, April. Leary argues that Morris's contribution to textile design began with two schemes for decorating Red House in 1860: The 'Daisy' pattern for a bed-room and 12 large figure and tree designs for the Dining Room. Fragments from the latter are now at the Victoria and Albert Museum, and the Fitzwilliam Museum, Cambridge.

1983 R. Gorjux and E. Hollamby La Red House, Ediziano Dedalo, Bari, Italy (series directed by Bruno Zevi). A re-appraisal of Red House in detail, photographs, plans and text (in Italian).

1984 Alan Bowness (introduction) The Pre-Raphaelites. Documents the 1984 major Tate Gallery exhibition of drawings, paintings and sculpture including colour illustration and description of 'Dantis Amor' painted by Dante Gabriel Rossetti on the centre door panel of the settle in Red House Drawing Room; side panels of 'Salutation of Beatrice' and 'Salutations in Garden of England' painted when the settle was still in Morris's studio in Red Lion Square. In 1863 side panels were removed and framed into Diptych and are believed to have been sold to raise funds for Morris, Marshall, Faulkner & Co. – 'the Firm'.

1985 A.R. Dufty Morris Embroideries – the prototypes published by the Society of Antiquaries, London. A valuable study of the sources of Morris's embroidery designs for the decoration of Red House. Most, perhaps all, were made at Red House; some, for the scheme of wall hangings for the Dining Room, were worked by Jane Morris and her sister Bessie Burden. After Morris left Red House, some of these embroideries went with him and are now at Kelmscott Manor; others are at Castle Howard.

1986 Jan Marsh 'William Morris's Painting and Drawing', Burlington, August. Marsh argues that Morris's interest in painting lasted longer than once thought and attributes, with evidence from pencil studies, the painted scenes on the hall settle at Red House to Morris.

1986 Deborah Nevins 'Morris, Ruskin, and the English Flower Garden', Antiques, 129, June. Nevins argues that with his garden at Red House, his poetry and prose, and his wallpaper designs, Morris helped revive the 'flower garden' and with Ruskin helped to articulate the relationship between landscape design and art.

1986 Peter Blundell-Jones 'Masters of Building: Red House', Architects Journal, 15th January (photographs by Martin Charles). A beautifully illustrated description of Red House and re-appraisal of its qualities as a seminal work of architecture and the symbolic as well as functional significance of its form and details.

1988 Ray Watkinson 'Red House Decorated', Journal of William Morris Society, vol. 7, Spring. A re-appraisal of attributions of painted furniture at Red House.